photographing Big Sur

Where to Find Perfect Shots and How to Take Them

Douglas Steakley

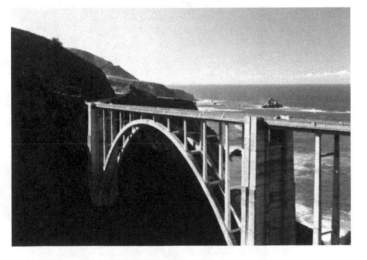

THE COUNTRYMAN PRESS
WOODSTOCK, VERMONT

Maps by Paul Woodward, © The Countryman Press
Book design and composition by S. E. Livingston

Photographing Big Sur
978-0-88150-928-1

Published by The Countryman Press,
P.O. Box 748, Woodstock, VT 05091

Distributed by W. W. Norton & Company, Inc.,
500 Fifth Avenue, New York, NY 10110

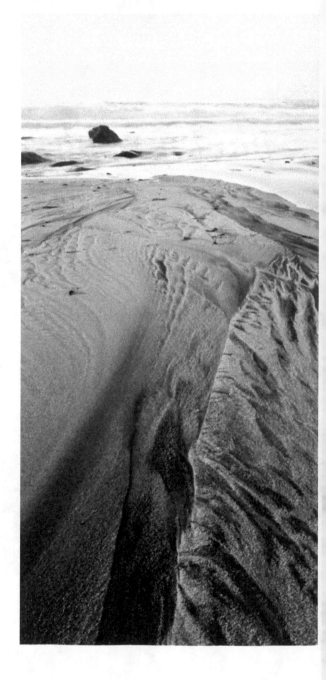

Title Page: Bixby Bridge from the Old Coast Road
Right: Garrapata Beach

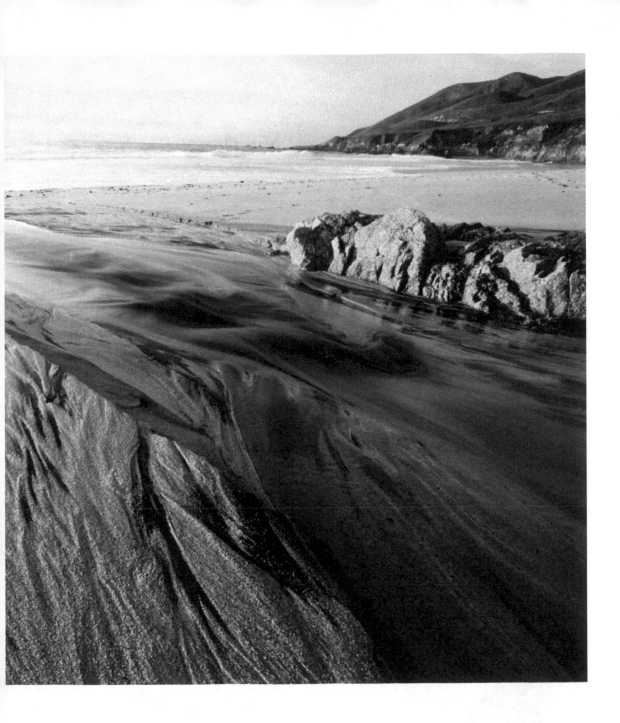

*Dedicated to Jackie and Nicole,
with thanks and appreciation for
their support and encouragement.*

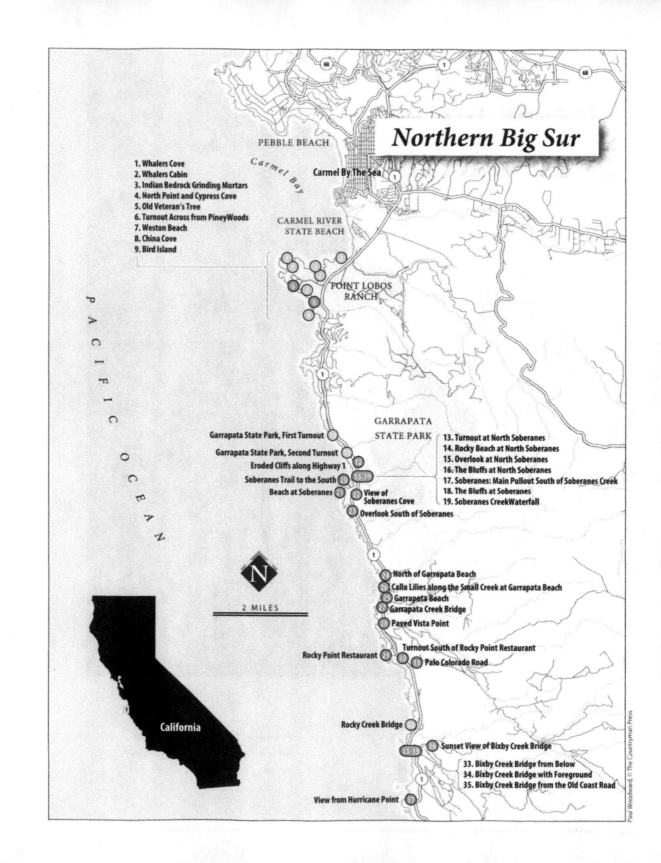

Northern Big Sur

1. Whalers Cove
2. Whalers Cabin
3. Indian Bedrock Grinding Mortars
4. North Point and Cypress Cove
5. Old Veteran's Tree
6. Turnout Across from PineyWoods
7. Weston Beach
8. China Cove
9. Bird Island

13. Turnout at North Soberanes
14. Rocky Beach at North Soberanes
15. Overlook at North Soberanes
16. The Bluffs at North Soberanes
17. Soberanes: Main Pullout South of Soberanes Creek
18. The Bluffs at Soberanes
19. Soberanes CreekWaterfall

Garrapata State Park, First Turnout
Garrapata State Park, Second Turnout
Eroded Cliffs along Highway 1
Soberanes Trail to the South
Beach at Soberanes
View of Soberanes Cove
Overlook South of Soberanes

North of Garrapata Beach
Calla Lilies along the Small Creek at Garrapata Beach
Garrapata Beach
Garrapata Creek Bridge
Paved Vista Point
Turnout South of Rocky Point Restaurant
Rocky Point Restaurant
Palo Colorado Road

Rocky Creek Bridge
Sunset View of Bixby Creek Bridge

33. Bixby Creek Bridge from Below
34. Bixby Creek Bridge with Foreground
35. Bixby Creek Bridge from the Old Coast Road

View from Hurricane Point

PEBBLE BEACH
Carmel Bay
Carmel By The Sea
CARMEL RIVER STATE BEACH
POINT LOBOS RANCH
GARRAPATA STATE PARK
PACIFIC OCEAN
California

N
2 MILES

Paul Woodward, © The Countryman Press

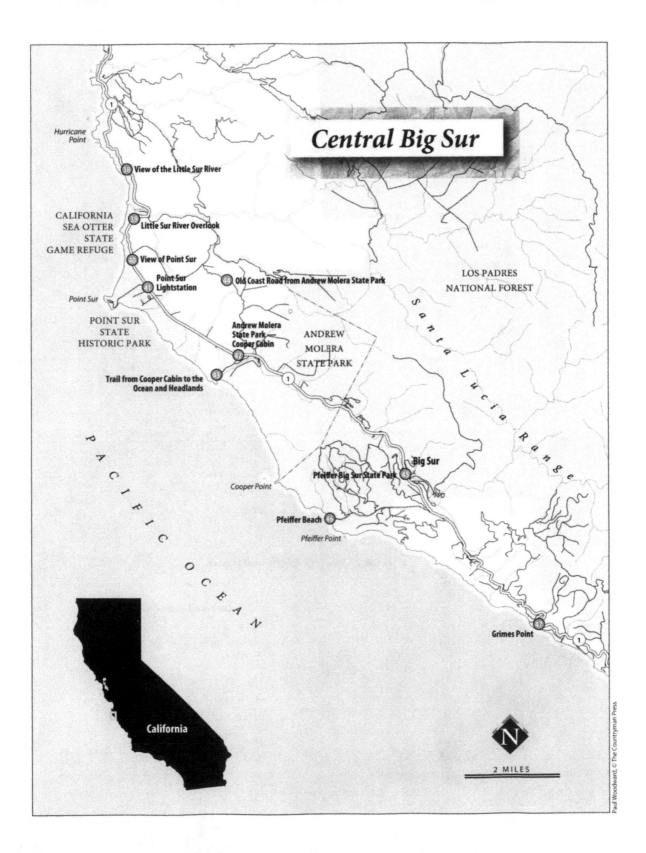

Central Big Sur

Hurricane Point

38 View of the Little Sur River

CALIFORNIA
SEA OTTER
STATE
GAME REFUGE

39 Little Sur River Overlook

40 View of Point Sur

Point Sur

41 Point Sur
Lightstation

24 Old Coast Road from Andrew Molera State Park

LOS PADRES
NATIONAL FOREST

POINT SUR
STATE
HISTORIC PARK

Andrew Molera
State Park—
Cooper Cabin

42

ANDREW
MOLERA
STATE PARK

S a n t a L u c i a R a n g e

43 Trail from Cooper Cabin to the
Ocean and Headlands

1

Big Sur

Pfeiffer Big Sur State Park 45

Cooper Point

Pfeiffer Beach 46

Pfeiffer Point

Grimes Point 47

1

P A C I F I C O C E A N

California

N

2 MILES

Paul Woodward, © The Countryman Press

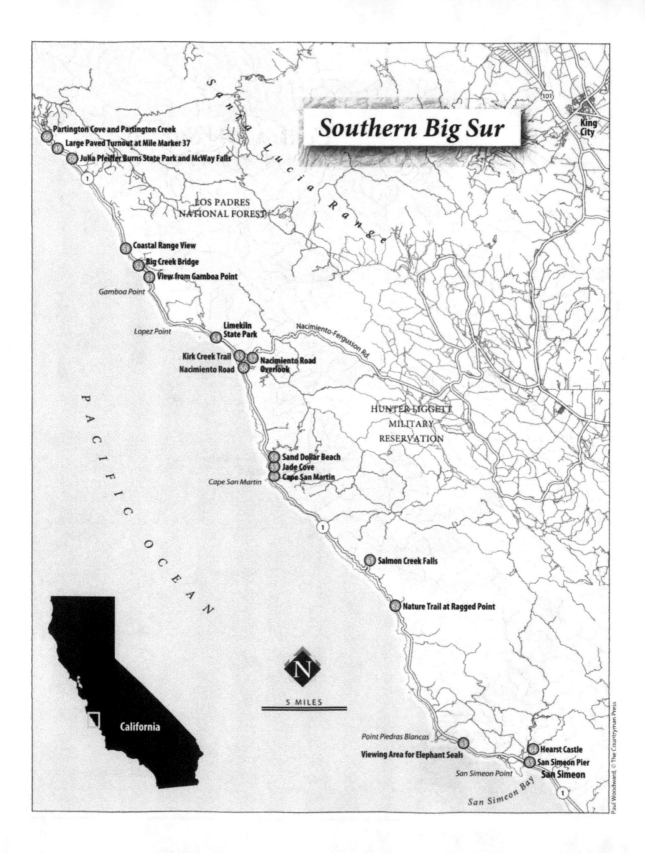

Southern Big Sur

- 48 Partington Cove and Partington Creek
- 49 Large Paved Turnout at Mile Marker 37
- 50 Julia Pfeiffer Burns State Park and McWay Falls

LOS PADRES
NATIONAL FOREST

Santa Lucia Range

101

King
City

- 51 Coastal Range View
- 52 Big Creek Bridge
- 53 View from Gamboa Point

Gamboa Point

Lopez Point

Nacimiento-Fergusson Rd.

- 54 Limekiln State Park
- 55 Kirk Creek Trail
- 56 Nacimiento Road
- 57 Nacimiento Road Overlook

HUNTER LIGGETT
MILITARY
RESERVATION

- 58 Sand Dollar Beach
- 59 Jade Cove
- 60 Cape San Martin

Cape San Martin

PACIFIC OCEAN

1

- 61 Salmon Creek Falls

- 62 Nature Trail at Ragged Point

California

N

5 MILES

Point Piedras Blancas

- 63 Viewing Area for Elephant Seals

- 64 Hearst Castle
- 65 San Simeon Pier
San Simeon

San Simeon Point

San Simeon Bay

1

Paul Woodward, © The Countryman Press

Contents

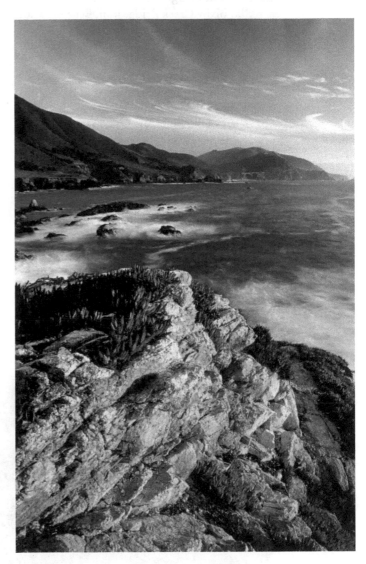

Rocky Point

IV. Bixby Creek Bridge Area

V. South Coast of Big Sur

Mother and baby sea otter

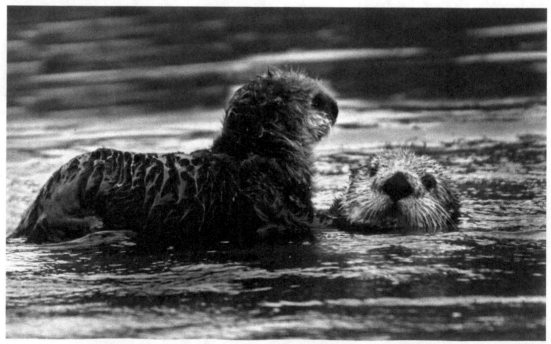

Introduction

California's rugged Big Sur coastline follows CA 1 (best known as Highway 1 or Route 1) as it heads south from the Carmel Highlands down to San Simeon and the Hearst Castle. Driving from the south, the route begins in San Luis Obispo County and continues north into Monterey County. This portion of Highway 1 is considered one of the most beautiful drives in the world, as the rocky coast rises from the Pacific Ocean, forming the towering hills and mountains of the Santa Lucia Range, home to the environmentally protected Ventana Wilderness and Los Padres National Forest. As you drive along the coast the scenery alternates between stunning ocean views, rolling hills and green pastures stretching along both sides of the highway. The landscape painter Francis McComas described it as "the greatest meeting of land and water in the world." Highway 1 along the Big Sur coast has been named a National Scenic Byway and a California Scenic Highway, designations reserved for roadways so distinctive, they are considered destinations unto themselves. This spectacular coastline attracts tourists from all over the world.

The Big Sur coast is dotted with numerous state parks, which provide access to hidden beaches and protected rocky coves. There are many pullouts along the ocean side of Highway 1, and often a short walk will lead to breathtaking vantage points that vary with the time of year, the tides, the weather, and the skies. For photographers, Big Sur is rich with possibilities. During the rainy winter months the hillsides turn emerald green, while in the summer and fall they are transformed into a rich golden color. In the late winter and early spring, March and April, a variety of wildflowers cover the hillsides—purple and yellow lupines, orange California poppies, and yellow mustard, to name a few. Fog often shrouds the shoreline during the summer months but typically gives way to clear skies in September and October, and bright, beautiful days are common in the winter. Winter storms bring dark clouds with much needed rainfall and often provide the most dramatic and interesting light for photography. Winter rains also bring mudslides, which can cause the closure of sections of Highway 1 for days at a time.

Aside from the striking scenery, a wide variety of wildlife populates the Big Sur coast. In the winter months, California gray whales are clearly visible during their annual southern migration to protected coves along the Baja California peninsula in Mexico, where females give birth in February and March. Then the mothers and their young begin the long and treacherous trip north to Alaska, often staying very close to shore. On calm days it is easy to spot the spouting whales as they migrate up or down the coast. California condors are now a common sight in Big Sur, where the captive-breeding program that began many years ago has been so successful that released condors are once again breeding in the wild. Many other birds frequent the coastline; among my favorites are the brown pelicans that fly low across the water in long, undulating lines. During December elephant seals come ashore near San Simeon and are easily accessible for viewing and photographing. The elephant seals remain on the beach near San Simeon most of the year, but they are particularly interesting in December, when the large males battle for their harems and the females begin giving birth to the young weaners. Other sea mammals include harbor seals, sea lions, and

Neptune Pool, Hearst Castle

sea otters, which can be observed from many locations along Highway 1.

The name "Big Sur" is from the Spanish *el sur grande,* "the Big South." The designation refers both to the coastal region and the community of Big Sur, which is located along CA 1 in Monterey County about 25 miles south of Monterey. Because the community has no central location, travelers often find themselves wondering if they missed it. About 20 miles south of Monterey the highway turns inland, briefly following the Big Sur River and passing through redwood groves around Pfeiffer Big Sur State Park. Many of the community's spectacular houses are obscured, well hidden up dirt roads behind locked gates. However, the community of Big Sur offers many excellent restaurants as well as a variety of options for lodging and camping. Big Sur also has excellent hiking trails that quickly lead into the backcountry and reveal an aspect of the Los Padres wilderness that can only be experienced on foot. A ranger station on the east side of Highway 1 in Big Sur has maps and helpful tips and advice from local rangers.

How to Use This Book

The winding and sometimes narrow two-lane highway along the Big Sur coastline offers sweeping seascapes and breathtaking coastal mountain views. At times the road dips low and close to the water; at other times it reaches heights of over 2,000 feet, providing towering panoramic views to the north and south.

This book follows a north-to-south progression, beginning in Monterey County with Point Lobos as the northernmost photographic area and ending in San Luis Obispo County at San Simeon and Hearst Castle, about 90 miles to the south.

Highway 1 features small white mile markers on both sides of the highway, and I have used these to indicate locations for many of the sites described here. The first site covered is at about mile marker 68, with other locations following southward across the San Luis Obispo County line. Since the mile markers are on both sides of the highway, this guide can be easily followed whether you're driving north or south. I also give GPS coordinates (degrees, minutes, seconds) for most locations, which usually refer to the spot where I parked my car, not where I ultimately stopped to take photographs. This will allow for some variation in the images produced, since not everyone following this book will shoot from the exact same location. I have spent many days and evenings photographing along the Big Sur coastline, and in this book I share my favorite locations, some of which would be difficult to locate without assistance. You may decide on other vantage points or views. A short walk from many of the turnouts along the Big Sur coast will lead visitors to locations that will result in much stronger images than are possible just standing by the side of the road. It is always well worth the effort to scout out an optimal vantage point for your shots, and in Big Sur you usually do not have to go very far to find a different perspective resulting in a stronger image.

This guide does not provide information on every turnout along Highway 1; what you will find are the locations that I feel offer the best possibilities for good images. It is not my aim to discourage readers from trying other turnouts and other trails not included here. You may find yourself in the right place at the right time for a strong photograph in a location that I may have overlooked or visited when the lighting was not quite right. It is always rewarding to seek out and find locations that offer new and unique perspectives, and Big Sur offers ample possibilities for doing so.

This guide is intended for photographers of all skill levels, from curious beginners to intermediate photographers and professionals who are unfamiliar with the area. Keep in mind that although Big Sur has always attracted photographers, both amateur and professional, it is always possible to go to a well-known, frequently photographed location and come away with something fresh and unique. The time of day, whether it's cloudy or clear, high or low tide, and the wind and wave action are all factors that determine how an image appears, and in Big Sur these factors are continually in flux.

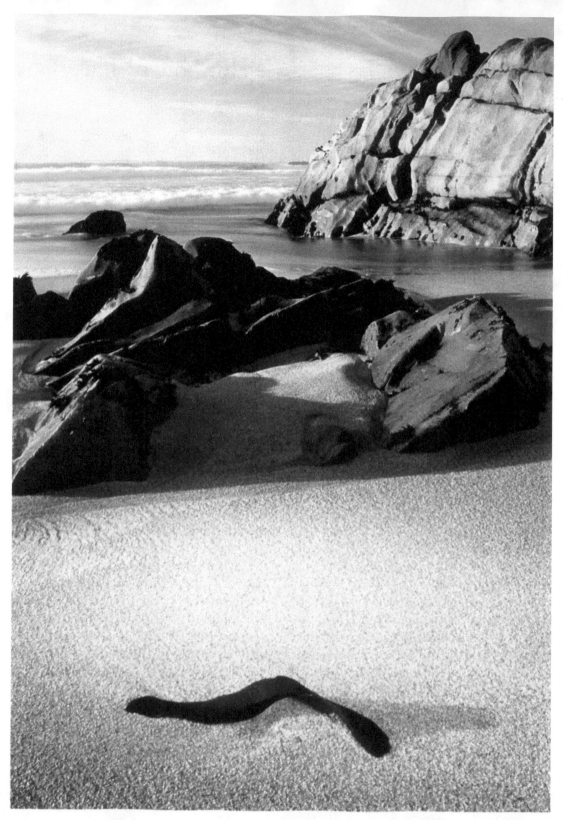

Kelp at Garrapata Beach

How I Photograph the Big Sur Coast

Visually, the Big Sur coast varies dramatically throughout the year and even throughout the day. Winter and spring months are my favorite times to visit and generally they are the best for photography, but the coastal area offers ample possibilities no matter the season or current conditions. For instance, the pines and cypress trees in Point Lobos are wonderful to photograph in the summer fog, when they have a moody, mysterious look. Foggy weather can also enhance black-and-white images. Generally I prefer to photograph in the afternoon and evening, when the low angle of the sun creates more dramatic, warmer and softer lighting. I look for shots in which the setting sun creates a sidelight as opposed to shooting directly into the sun. That said, there are locations along the coast where the morning light is preferable—so it becomes a matter of knowing where to go and what to look for given the conditions that occur on any particular day.

If you are photographing tide pools you need to be aware of the changing tides. I always look for a minus tide occurring in the late afternoon or at sunset, or when the weather is cloudy or overcast. Minus tides occur when the tide level is very low, allowing you to walk farther out on the exposed rocks and discover sea life in the tidal basins. Minus tides are the best time to find and photograph the brightly colored starfish that make or enhance strong tidal pool images.

Be careful when the tide is low but rising, because an unexpected large wave can take you by surprise. I have seen quite a few photographers along the coast with wet shoes and pants, and have been caught off-guard by rogue waves myself. I remember one evening when I was standing on a bluff above the ocean. The rocks I was standing on were dry and I noticed a large wave coming toward me. I thought, "That's a big wave!" and had just enough time to turn and grab the rock wall in front of me as the wave crashed onto the rock and covered me about waist-deep. Fortunately I had left my camera above this location, but my evening was over. I was soaked, cold, and shaken. It is not uncommon to see stories in the local paper about people being swept into the ocean by large waves.

That said, the wave action here is part of what makes Big Sur attractive to photographers. I enjoy photographing during stormy conditions or just after a storm has blown through. There are many locations along the Big Sur coast where you can see waves crashing against the rocks and sending spray high into the air, and if you time your exposures just right you can capture these powerful moments. Crashing waves also offer photographers a good opportunity to practice exposure speeds, since slower exposures sometimes show more softness in these images.

Precautions to Take When Photographing in Big Sur

The following words of caution stem from my personal experience in photographing along the Big Sur coastline.

First, watch out for poison oak when hiking around Big Sur. This plant, which causes an itching skin rash, borders and in some cases has overgrown many of the area's trails. Learn how to identify poison oak and avoid coming in contact with it. Wear long pants and covered

shoes, and don't touch the plants with bare hands. Although many of the plants lose their leaves in winter and fall, the branches can still transmit the rash, which usually takes several days to appear and lasts for about a week.

Second, be on guard against theft when leaving your car unattended along Highway 1. My wife and I have both returned to our parked cars to find windows smashed and items stolen from within. Break-ins can be discouraged by parking your car perpendicular to the road instead of parallel, so that both sides of the car are visible to passing traffic. Do not leave any valuables in sight and carry all of your camera gear with you. Whenever possible, I try to photograph from a location where I can see my car, but this is not always an option.

The third warning has already been mentioned but is *very* important: always be on the lookout for incoming waves. Not all waves are created equal, and every once in a while an unusually large wave will come ashore. These are the waves the surfers wait for—they are good for surfers but not for photographers. I have been surprised by exceptionally large waves several times and have seen other photographers up to their knees in the surf. Not only can such waves get you wet and damage your equipment, they can be very dangerous if you are swept into the pounding surf.

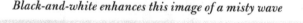
Black-and-white enhances this image of a misty wave

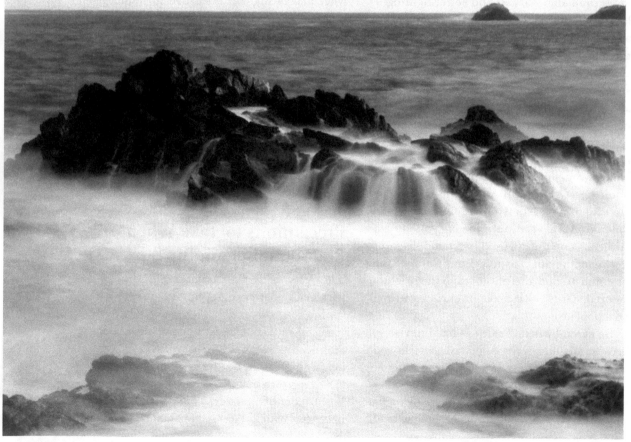

Storm over Garrapata Creek

Digital Photography and Postprocessing

The introduction and wide use of digital cameras has had a profound impact on both professional and amateur photographers. Digital photography has almost totally replaced film over the past several years and photographers have more or less been forced to accept and embrace some of the new and complex technologies associated with digital imaging. I remember my initial reluctance very well; for a time I carried two cameras on two tripods, one a traditional film camera and the other a new digital camera, which I did not trust. But learning to use the new digital camera proved to be the easy part of making the transition: it is the

postprocessing aspect of digital that is daunting. Unless you are willing to shoot JPEGs in order to make smaller prints, processing images requires some familiarity with a computer and a program such as Adobe Photoshop.

The real benefit of digital photography lies in the ability to shoot raw files capturing all the available data, but raw files have to be processed and subsequently converted to TIFF and JPEG files. When you shoot in JPEG format, the camera does the processing for you and makes irreversible decisions about several aspects of the image, such as hue, saturation, contrast, and exposure, and in this process

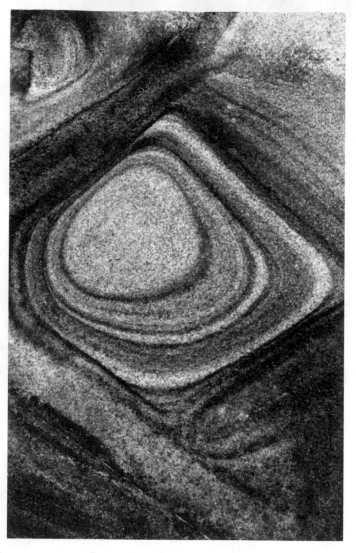

Pattern in rock

dars, greeting cards, books, and magazines, require TIFF files. At some point all serious photographers begin photographing in raw format, taking the time to learn a processing program such as Adobe Photoshop or Aperture.

Learning Photoshop is a bit like learning a foreign language—you first learn a few phrases and then slowly add to them. It takes repetition and constant use for the tools in Photoshop to become familiar. But like a second language, it is also exciting and opens up a world of new possibilities. Furthermore, the quality of digital photography has improved so dramatically that higher-quality digital cameras now compete favorably with medium-format film cameras. Digital photography has many benefits: you can review images on the camera monitor and make changes to your exposure and composition immediately, and digital is "free," in that there are no film or developing costs—only your time to review the many images you have taken. These advantages are even more significant when shooting wildlife, because it is now possible to take many shots of an exciting scene or event without worrying about the expense of the film or processing. Shooting digitally also avoids the expensive scanning process, and files can easily be saved as raw, TIFF, and JPEGs. Because of these and other advantages, I encourage anyone who has not already taken the plunge to acquire a processing program. There are numerous workshops and classes in Photoshop, Aperture, Lightroom, and other imaging programs that will help you develop and improve your photography skills.

In spite of the transition to digital photography, the aesthetic and most technical aspects of photography have not changed. You still have to be in the right place at the right time; getting the correct exposure is critical; and composition and depth of field remain essential ingredients of a strong image.

Photography remains a personal art form,

deletes or discards the information that is not included in the final image. JPEG files can be improved in Photoshop to an extent, but it is not the same as shooting in raw format, where the camera captures all available information and processing is left to the photographer. JPEG files are much smaller than TIFF files, which are created from raw files; consequently JPEG files can only be made into smaller prints. Many photography contests now require that submissions be TIFF files, and most commercial photography uses, such as calen-

and the best images are unique and compelling. So take your time, give careful consideration to your subject matter, and become familiar with your equipment. A good image presents the familiar with a directness and immediacy that often takes the viewer by surprise.

Guidelines for Improving Your Photography

Heed the Rule of Thirds

The rule of thirds is a basic rule of composition in which the page or image is conceptually divided into thirds both horizontally and vertically—imagine two equally spaced lines crossing the page from top to bottom and two equally spaced lines crossing the page from side to side. The four points at which these lines intersect become the approximate locations where the subject matter of the photograph should be placed. This removes the subject from the center of the photograph, resulting in an image that is more interesting and compelling. The off-center placement creates a visual tension by making the viewer look both at the subject and at the offsetting "empty" or negative space, making the entire composition more dynamic. So remember, when you are framing a photograph through the viewfinder, be sure to place the subject off-center, preferably at one of the four points of intersection.

The rule of thirds can also be applied to horizon lines. Instead of splitting a scene with the horizon line placed across the center, you can create a more interesting image by placing the horizon line so that two-thirds of your composition is sky, for example, and one-third is foreground (or vice versa).

Little Sur River, framed using the rule of thirds

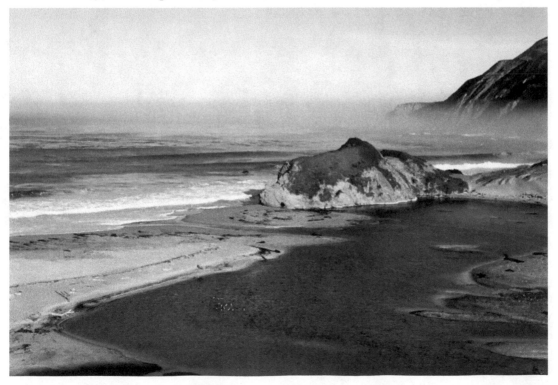

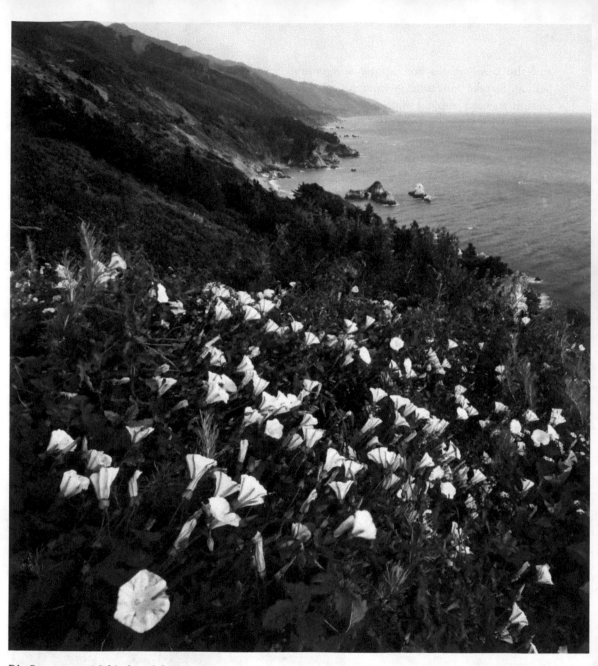

Big Sur coast, with bindweed flowers in foreground

Use Perspective—Foreground, Middle Ground, Background

When taking photographs of large scenic vistas, remember that they will have much more impact if something is included in the foreground. Having a subject, such as a flower or interesting rock, in the foreground allows the viewer to be led into the image and gives a sense of depth and perspective. When you compose this way, be certain that the foreground is in sharp focus. Using a wide-angle lens, such as an 18–24mm, allows the back-

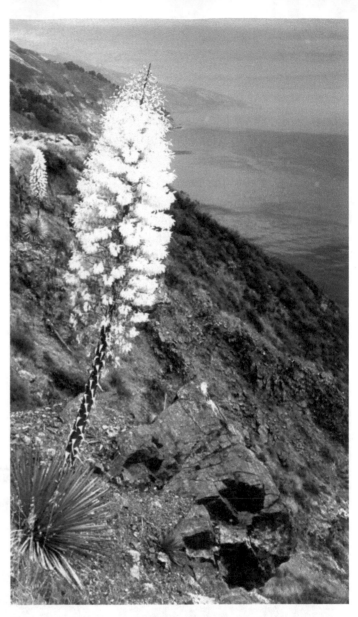

With flowering yucca in foreground

ground to also remain in focus. Depending upon the particular wide-angle lens, when the focus is set on infinity, generally everything 15 to 18 inches from the camera and beyond will be in focus and can be included in your composition. Focusing on the foreground to create

depth does not work as well with midrange or short telephoto lenses, as these lenses are not able to maintain sharp focus over a broad area as well as wide-angle lenses.

Look For and Incorporate Leading Lines

A leading line can be anything that takes the viewer's eye into the photograph. It could be a fallen tree, a stream, or the shadowed edge of a

sand dune. Leading lines are most effective when they are diagonal rather than horizontal or vertical, and they are often placed in the lower left corner of a shot, to lead the viewer's eye into the center of the image or to the main subject.

Patrol the Border

"Border patrol" is a phrase that has been adopted by photographers to emphasize the importance of carefully framing the shot before taking a photograph. So often we just decide on a subject, place it in the viewfinder, and fire away. But later, when we look at the picture on a computer or make a print, we discover that there is something in the composition—a stray tree branch off to one side, for example—that detracts from the photograph. When composing an image in the field be sure to inspect the outer edges of the frame while looking through the viewfinder to be certain that nothing unwanted or distracting has made its way into the image. Be vigilant with border patrol!

Move Closer or Fill the Frame

One of the most common mistakes made by new photographers is trying to include too much in an image. Here are a couple of simple questions that I frequently ask myself when I am shooting: "What is the subject matter here?" "What do I want the viewer of this photograph to see?" Try to be clear and specific

Leading lines draw the viewer in

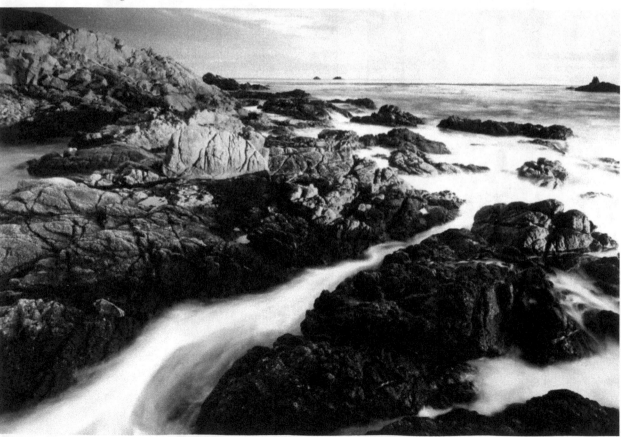

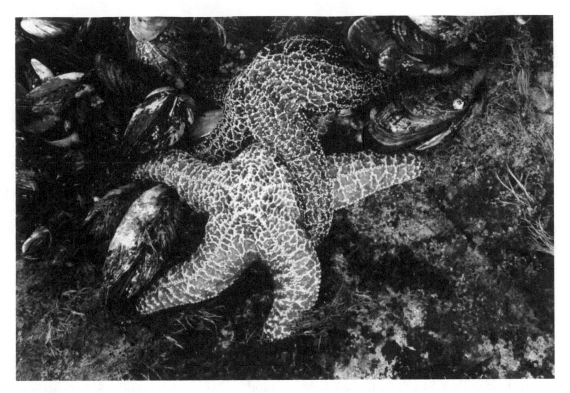

Mating starfish

and then look around the viewfinder and make sure that everything being included adds to the strength of the image. If it does not, then consider reframing the photo to leave out extraneous details. Photographs have a stronger visual impact if the subject matter is presented clearly and directly, without a lot of background detail competing for the viewer's attention. Often this means moving closer and filling the frame with the subject of the photograph. This technique becomes a little trickier with landscapes, but with most subject matter moving closer will result in a better image.

Use a Tripod

Using a tripod usually indicates a higher level of commitment on the part of a photographer. A tripod serves two purposes—it eliminates camera movement, or shake, which in turn creates sharper images, and it slows the shooting process down, forcing you to take more time to carefully compose an image.

A tripod becomes even more important when shooting landscapes, and here's why: when you shoot in Program or Auto mode, the camera's onboard computer will always try to make adjustments to attain a perfect exposure. In trying to achieve a perfect exposure the camera will make adjustments to the aperture and shutter speed and often open the aperture wider to increase the shutter speed. With landscapes you want to control the depth of field so that the image is in sharp focus from front to back, and this requires a smaller aperture such as f/14–f/18.

As the aperture number increases, the lens opening decreases, which reduces the amount of light that can pass through the lens onto

the image sensor (or film). To compensate for the reduced amount of light passing through the lens, the shutter speed slows down, so it remains open for a longer period of time, thus allowing additional light to pass through to balance the narrow aperture opening. As the shutter speed becomes slower, camera shake becomes almost inevitable and even the slightest movement of the camera while the shutter is open will cause the image to be soft and out of focus. This is where a tripod becomes essential. With the camera stabilized on a tripod you can close the aperture down to increase the depth of field and not worry about how slow the shutter speed becomes. Stabilizing the camera on a tripod also allows you to shoot at the lowest ISO setting, which will improve the resolution. This is why serious photographers always use a tripod whenever possible, especially when shooting landscapes.

Here's a rule of thumb about tripods—there are two kinds of tripods, those that are light and easy to carry around and those that are heavy and work well. If you are going to use a tripod you will be much better off with a heavier, more stable one. I use three tripods—a very lightweight one for backpacking or hiking long distances, a middleweight one for hiking shorter distances, and a heavier one, which I use when I can get it to the location.

Many newer cameras have a vibration reduction or internal stabilization feature which allows the shutter speed to be slower when the camera is handheld. This will reduce some of the camera shake, and it is a useful feature when it is not feasible to use a tripod, such as in a busy marketplace or when shooting wildlife. However, you should not rely on VR or IS to stabilize your camera when shooting landscapes and many other images, and that is not what these features are designed for. The bottom line is that if you are not already using one, a tripod will become an essential tool as

your interest in photography grows and you strive to obtain the best images possible.

If you are using a tripod in the sand or near the surf where it might get wet, be sure to extend the bottom legs far enough so that sand and water do not get into the upper legs and stop them from sliding smoothly. Also, when the tripod legs are wet or dirty it is better not to slide them all the way back into the upper legs. Wait until you get home and wash them off with regular water and dry them with a towel before closing the tripod.

Pay Attention to Lighting

Subject matter is only one element of an image, and it is arguably not always the most important of several elements. Interesting or dramatic lighting is often the key ingredient of a successful image. Sunrises and sunsets often provide the best lighting situations, because the light is horizontal instead of being overhead, and this sidelight often creates strong, dramatic shadows, which add texture and depth to photographs. Also, morning and evening light is warmer, which enhances the color range for reds and oranges. When the sun is overhead, the lighting often appears flat and not very interesting. A blue sky can have the effect of placing a large blue umbrella over everything, reducing the warmth and imparting a cool and sometimes harsh mood to images.

There are basically four types of light that are important for an outdoor photographer: soft or diffused light such as that produced when fog or clouds are present, sidelight, backlight, and front light. When composing an image it is important to pay attention to the direction the light is coming from and how this impacts the subject being photographed.

Soft light can be the result of fog, overcast, or shade, and increases the color saturation in softer, subtler tonalities. Soft light enhances or brightens colors that would be lost in the

harshness of direct sunlight. Stormy weather and wet, cloudy days also provide lighting that reduces contrast and makes colors richer and more vivid. One of my favorite lighting conditions is a clearing storm, when the clouds move across the image, creating dark and light cloud shadows on the scene. As storms move out, the grass on rolling hillsides is usually wet, which also enhances the saturation or depth of color.

Sidelight creates dark shadows by lighting one side of the subject while leaving the other side darker. This is great light for textured subject matter such as rocky cliffs and bluffs, or showing the depth in sand dunes. The dark shadows created by sidelight often become an important element in the image, which makes sidelight so attractive to photographers who prefer to shoot black-and-white images. Often when I am photographing along the coast at sunset I will turn to one side or the other to see the effect of the low, warm light instead of facing directly into the setting sun and photographing the sunset.

Backlight usually results in images with a strong contrast between the brighter light in the sky and the darker, unlit subject. This is the perfect light for creating silhouettes, because the camera's light meter will attempt to darken the sky to a mid tone and will darken the subject also. I often incorporate a flash with

Sunset brings out warm hues

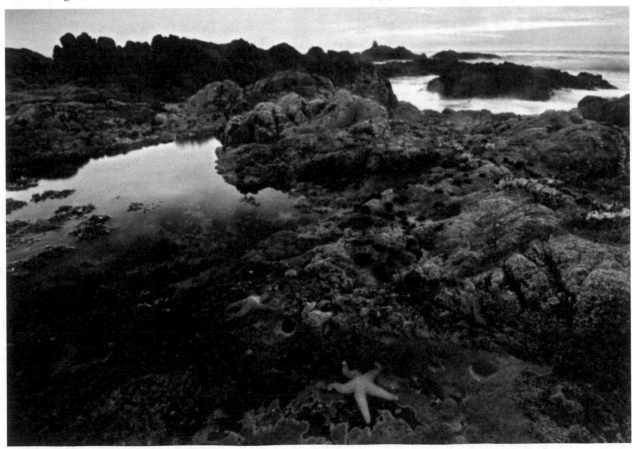

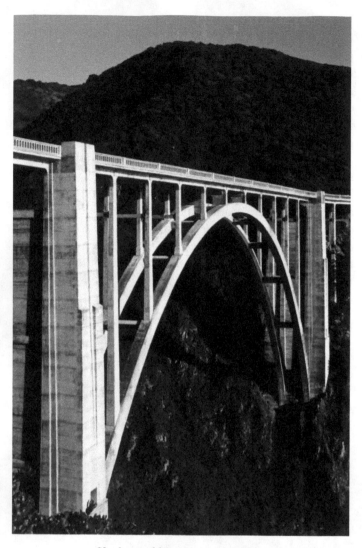

Shadows add interest to this photo of a bridge along Highway 1

backlighting in situations where I want light on the subject to bring out detail and avoid a silhouette. Backlighting also works well for translucent subjects such as large tropical leaves. Taking photographs in a backlit situation is difficult to master because of the wide range of tonalities in the image. It is not easy to have detail in most subjects when the background light is strong and causes the meter to

darken everything in the scene. You can overcome this somewhat by spot metering on the subject, but this may create a sky that is too light. When facing the sun, be sure to shade the lens to avoid lens flare, which is the highlighting or streaking that appear in your image from the sun reflecting off the front of the lens.

With front light, the sun is at your back and the subject is well lit; shadows are behind the subject. This type of light fully illuminates the scene and works well for subjects that have a lot of color and detail, such as a field of wildflowers. However, front lighting should be used judiciously, because it is often the flattest and least interesting of all light sources, particularly if the subject you are photographing does not contain a lot of color and differentiation.

Use the Camera's Histogram to Check Exposure

Histograms are one of the most useful tools incorporated into digital cameras, from simple point-and-shoot to more complex single-lens reflex (SLR) models. In my photography workshops I have come to realize that photographers often do not understand how histograms work and why it is so important to take advantage of them. Histograms can help immensely in obtaining the correct exposure by avoiding overexposed, or "blown out," highlights or unwanted dark shadow areas with no detail. Blown-out highlights can never be recovered, but there are times that dark areas are desirable; shadows cast by some subjects, such as sand dunes, best appear totally black. The most important thing is to learn to read and understand the information a histogram provides so that you have more control over the final image.

Each pixel taken with a digital camera is assigned a color, and these colors range from 1 (black) to 255 (white). A histogram displays these colors in a graph by selecting and grouping them together. Histograms read from black

to white, left to right—in other words, the dark pixels show up on the left-hand side and white pixels show up on the right-hand side. Histograms quickly show whether the image is over- or underexposed and allow you to make exposure adjustments while shooting. The most important information a histogram indicates is whether the shadow areas or highlight areas are being "clipped." If a shadow area is clipped, it may contain "noise"—the bright red and green specks that often appear in the darker areas of an image on a computer screen or in a print. Back when we used film, this was referred to as "grain," and although noise and grain are not exactly the same thing, their results are similar in that both are artifacts that you want to avoid as much as possible. Aside from noise, dark areas of an image contain little detail or information.

When a highlight area of a photograph is overexposed or blown out, it also contains no detail, and often the information missing in the image cannot be recovered. However, with digital photography it is easier to recover some detail from the bright areas of an image than from the darker areas. Clipping can be detected when the histogram bunches up against either the left or right side of the display panel, and can usually be corrected by making adjustments with the exposure-compensation control on the camera.

Generally it is desirable to have the histogram spread from left to right to cover the entire dynamic or tonality range that the camera can accommodate. This is usually a range of about five stops. However, you should bear in mind that the histogram is only a guideline or source of information and there are some instances where this type of reading will not produce the desired result. For instance, if you are shooting in the snow or fog and the photograph is light in tonality, then you would not expect the histogram to extend to the left side

of the frame; instead, all of the pixels would be in a group more to the right-hand side. Or if you are shooting with sidelight and creating dark shadows, you may want to retain these shadows and allow the histogram to be against the left-hand side of the display. Use the histogram as a tool to assist you in obtaining the best exposure, and remember that there is no perfect histogram that applies to every image or situation.

It is important to set your camera so that a histogram appears immediately after you shoot an image, and then to take a moment to look at it to see where the exposure is falling. With practice, you'll find that, rather than being mysterious or confusing, histograms are a great aid in determining the proper exposure. You can easily change the exposure of an image with the exposure-compensation adjustment that all digital cameras have. If the image is underexposed, try adjusting the exposure compensation by a half stop to the right, which indicates more exposure. The converse is true for images that appear to be overexposed on the histogram.

Many digital cameras also have a highlights warning indicator, which blinks when areas of an image are overexposed. I rely on these "blinkies" a lot, and when I see them I usually adjust the exposure-compensation dial about a half stop toward the underexposed direction and take a second shot of the same scene.

Learn to Use Filters

Neutral-Density Filters Neutral-density filters help balance variance between dark and light areas of an image. They are generally used when the sky is lighter than the foreground, and they are very useful along the Big Sur coast. When we look at a scene with a bright sky, our eyes can see detail in both the foreground and the sky, but the image sensor in a camera does not have the ability to properly expose areas in

a photograph that vary more than two or three stops. If the camera exposes for a bright sky, the foreground will be dark, and if it exposes for the dark foreground, the sky will be too bright. A neutral-density filter solves this problem by darkening the sky and evening out the tonality range of the image. This has the effect of lightening the foreground so that it contains more detail or visual information.

There are two types of neutral-density filters—round ones that screw onto the lens and rectangular ones that can be moved up and down either by hand or via a holder attached to the lens. The problem with round, screw-on filters is that the affected area is always in the center of the image, and there are many times when the horizon line is above or below the center. Rectangular filters work much better because they can be moved up and down and even turned at an angle, so they are effective when the sky is a larger or smaller portion of the image.

Not all neutral-density filters are created equal. Some of the less-expensive, lower-quality ones are called graduated gray filters, and they can place a blue or red cast on part of the image. Better neutral-density filters are truly neutral and will not create this color shift—so be discriminating when you are selecting a neutral-density filter.

Neutral-density filters come in different strengths and can be either graduated or hard-edged. When shooting along the ocean, where there is a clear delineation between the sky and the foreground, a hard-edge filter works well. But if there are portions of the image such as hills or trees that extend into the sky, then a graduated filter will work better because it blends the transition between light and dark. The various strengths are one stop, two stop, three stop, et cetera; these refer to the difference in lightness or darkness between the upper and lower portions of the filter and the

difference in the number of f-stops between the sky and foreground.

To determine which strength of filter to use, take a light reading from both the foreground and background and calculate the difference in f-stops. I have found that a two- or three-stop filter will work well for most situations. Or you can take a photograph and look at the small monitor on the back of the camera. If the sky is still too light, then try a stronger filter, moving from a two-stop to a three-stop or more until you get the result you are looking for. I sometimes stack two neutral-density filters, a two-stop hard edge and a two-stop soft edge, to make the sky even darker.

It is also possible to take two images that are exposed differently, one for the sky and one for the foreground, and blend them together in Photoshop, and there are times when this is the best solution. High dynamic range (HDR) imaging also makes it possible to take a series of images, some overexposed and some underexposed, and blend them together in Photoshop. This is a fairly simple process that has become part of many photographers' shooting techniques. However, even with these other options, I always use neutral-density filters, especially when photographing along the Big Sur coast.

Circular Polarizing Filters A circular polarizing filter is one filter that every photographer should have in their camera bag, because the effects of a polarizer cannot be duplicated in Photoshop or any other program. The main use of a circular polarizer is to reduce or eliminate glare or reflected light, and there are several situations where a polarizing filter is helpful.

Polarizing filters reduce or remove the spectacular highlights from the surface of water, which makes water both more transparent and less reflective. If you want to include rocks or other objects that are under water and make

them a part of the image, a polarizer will do this. The transparency is increased as you shoot from a higher angle into the water and reduced if you are down low and shooting across the water.

If you are photographing plants or foliage after a rain, or if plants are in an environment with dew or fog, a polarizer will reduce the glare from the water droplets and consequently saturate the colors of the foliage. It will also tend to darken the shadow areas, making the lighter plants stand out even more against the dark background. You can also use a polarizer with rainbows, but be careful because rainbows are made up of polarized light, and the colors will be totally eliminated if the polarizer is turned all the way. On the other hand, a minimal amount of polarization will enhance rainbows, making colors stand out more. Many skies, particularly skies with clouds, have tiny water droplets in them. A polarizing filter will reduce or eliminate glare from these droplets and make the sky darker and clouds more distinct.

Polarizing filters work best when you are shooting at a 90-degree angle from the sun, and do not work at all if the sun is directly in front of or directly behind you. I always look at my own shadow and try to shoot so that it is more or less perpendicular to the direction I am photographing.

A word of caution: in some situations a polarizer will turn part of the sky much darker than the rest, so the resulting image will have an uneven tonality. Skies often have this uneven tonality anyway, but a polarizer makes it more pronounced. This effect is more apparent when shooting with a wide-angle lens. Also, if you are at a high elevation, above 4,000–5,000 feet, a polarizer will turn the sky a very dark blue or even black, so use polarizers sparingly above 4,000 feet.

If you are taking several images to stitch them together as a panoramic, you should not use a polarizer. The uneven tonality of the blue sky in the different images prevents the images from blending together seamlessly.

A circular polarizer, when used at full strength, requires about 1.5–2 stops of additional light. This means that if you are shooting at 1/125 of a second at f/16, you will have to open the aperture up to about f/11 to maintain the same shutter speed. Because polarizing filters require more light, I rarely use them when photographing wildlife or any moving target where I want a fast shutter speed to freeze the action. On the other hand, if you want to soften or blur the action, such as when photographing moving water or a waterfall, then a polarizer will be helpful because it will slow the shutter speed. A polarizer will also tend to darken shadow areas, making the areas surrounding a waterfall darker and increasing the contrast with the moving water.

You can readily see the effect of a polarizer by either placing it on the camera and turning it or simply by holding it in front of your intended subject and turning it. If you do not notice any effect from the polarizing filter as you turn it, it probably will not improve the scene you are looking at.

All digital SLR cameras will require a circular polarizer, one that can be rotated. Because it is such an important and useful filter it is a good idea to purchase the highest quality (read: expensive) you can find. It is possible to purchase only one filter to fit your largest lens size and purchase much less expensive step-up rings to attach the polarizer to smaller lenses.

Polarizing lenses come in two different thicknesses: regular and thin. You will need a thin one to avoid vignetting the image (creating dark corners) when you use a wide-angle lens. Thin polarizing lenses are more expensive, but if you are going to purchase only one, I recommend choosing a thin one that will fit your largest lens.

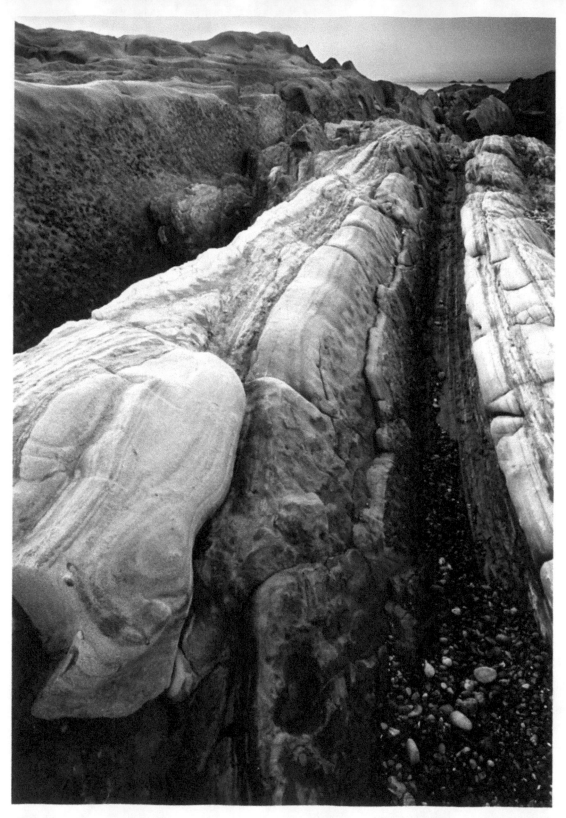

Weston Beach

I. Point Lobos State Natural Reserve

Point Lobos State Natural Reserve is open from 8 AM until a half hour after sunset. Dogs are not allowed in the park, and cannot be left in cars parked there. There is an entry fee ($10 per passenger car), which can be avoided if you park along CA 1 and walk into the park, but be advised that this is a location where break-ins have been reported, so take precautions if you choose to leave your car unattended along the highway. Although Point Lobos is arguably not part of the Big Sur coast, which begins a few miles to the south, below Mal Paso Creek, I have included it in this book for several reasons. First, Point Lobos has always been a destination for photographers, from Edward Weston and Ansel Adams to contemporary photographers who live in the Monterey area and beyond. This state park also has the advantage of being readily accessible, with miles of walking trails, many of which hug the rocky shoreline. It offers a variety of possibilities for photographers, including the chance to explore tide pools and the colorful starfish and anemones that can be found there, and view the striking cypress trees, with their angular branches and white bark, that are the subject of many fine art photographs. Point Lobos can be an overwhelming destination for visitors unfamiliar with the area, especially if time is limited; this guide will help you get your bearings. Also, the discussions take into consideration weather and lighting concerns at Point Lobos. There are locations that photograph particularly well in sunlight, and others for which foggy or stormy conditions are optimal. However, Point Lobos offers an array of photographic opportunities, no matter the conditions you may have at the time of your visit.

Numerous movies have been filmed in and around Point Lobos, beginning in 1914 and continuing today, among them *A Summer Place, The Sandpiper,* and *The Graduate.* There are many photogenic locations in Point Lobos; for this book I have selected several of my favorites. Some of the trails go farther inland and wander through pine forests but I focus on the more visually interesting coastline trails. Be sure to ask for a map at the entrance station and explore as much of the park as you can in the time you have. Point Lobos is one of the treasures of the California State Park System; it's no surprise that photographers are drawn here.

www.pointlobos.org
831-624-4909

Whalers Cove Area

Whalers Cove (1)
GPS coordinates: 36°33'3" N, 121°55'46" W

As you enter the park, the first right turn heads down a hill to Whalers Cove. This sheltered cove remains calm year round and is now a favorite with scuba divers. Although the cove is not among my favorite places to photograph at Point Lobos, during the spring, usually in April, many newborn harbor seal pups can be found on the shores of the sandy beaches, and they are close enough to photograph with a small telephoto lens. I have also found Whalers Cove to be a good location for taking photographs of great egrets and blue herons as they ride on top of the kelp, searching for small fish.

Point Lobos contains more than 45 prehistoric Native American sites. The Rumsien tribe was located in this area for more than 2,500 years, and it is still possible to locate abalone shell middens and bedrock mortars. This area

was the largest Indian site in Monterey County. After the early Spanish explorers "discovered" the area and used it for cattle, it was populated by a series of ethnic groups with varying interests, beginning with a small group of Chinese families, followed by Portuguese and Japanese whalers. Point Lobos was once the site of a large Japanese abalone farm; it has also served as a dairy farm and gravel quarry. In 1933 the state of California purchased the land for a state park, and Whalers Cove became the first underwater reserve in the United States.

Whalers Cabin (2)

As you walk back up the hill from the parking lot at Whalers Cove, the old Whalers Cabin is a striking sight, with large cypress trees and whale bones framing it on either side. The gray cabin photographs particularly well on foggy or overcast days, when the soft light matches the structure's sagging roof and weathered redwood planks. The cabin was originally built in the 1850s, as one of several residences for a small group of Chinese fishermen who took up residence on the western shore of the cove. It has seen many uses over the years, including serving as headquarters for the U.S. Army Coastal Defense Squad during World War II. In 2007 it was added to the registry of National Historic Landmarks. The cabin now houses a small museum that is well worth a visit.

If you go the other direction out of the Whalers Cove parking lot, you will come to a short set of stairs leading up the hill and out toward Cannery Point. Take the left onto North Shore Trail to access one of my favorite walks in Point Lobos. As you follow the North Shore Trail there are numerous opportunities along

Harbor Seal in Whalers Cove

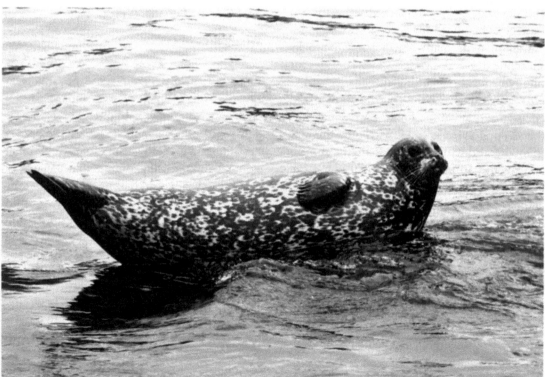

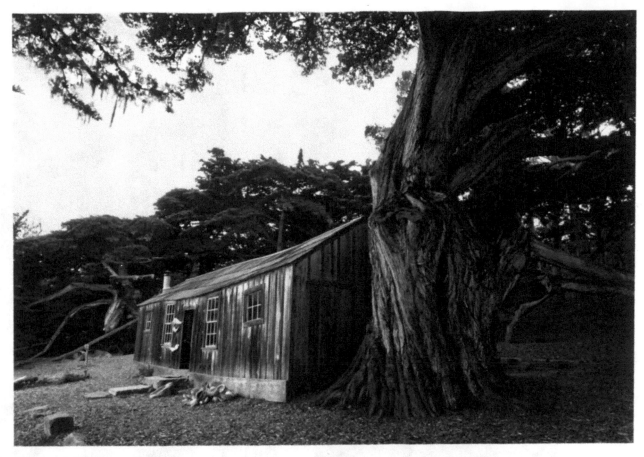

Whalers Cabin

the shoreline to photograph the rocky coast. The trail continues along the shoreline all the way to the reserve's main parking lot at Sea Lion Point and the Information Center, through groves of cypress and pine trees. However, if you take a left on Cabin Trail, it will take you in a small loop back to the Whalers Cabin.

Indian Bedrock Grinding Mortars (3)
GPS coordinates: 36°31'23" N, 121°55'49" W

To reach this group of bedrock grinding mortars, walk behind Whalers Cove on the Granite Point Trail. The trail is made up of broken abalone shells from the time when abalone was harvested here. This trail leads through a pine forest to Coal Chute Point and, a little farther on, to Granite Point. A loop trail leads up to Granite Point, which offers views to the north of the long sandy beaches of Carmel and Pebble Beach. At the trail intersection take a right on Moss Cove Trail and walk about 0.25 mile to the end of the reserve boundary. This trail leads through an old pasture and is a recent addition to Point Lobos State Natural Reserve. The pasture is slowly being turned back to natural growth and is a good location for viewing deer and great blue herons. As you approach the end of the trail you will come to a small spur, which leads off to the right to

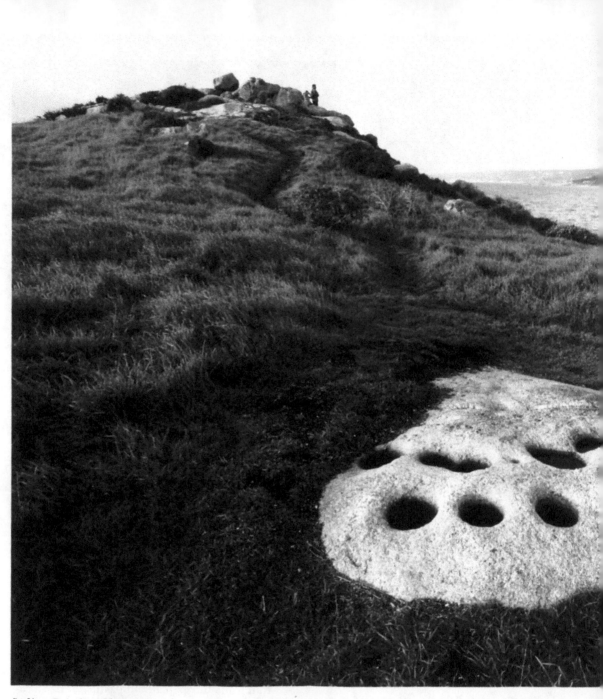

Indian Grinding Mortars

several large granite rocks protruding from the soil. Look closer and you will see several deep depressions in the rocks; these are bedrock mortars, once used by the Esselen Indians to grind seeds and nuts into meal. These mortars can be found all along the Big Sur coastline, and they are always near the many creeks that flow from the Santa Lucia Range into the ocean.

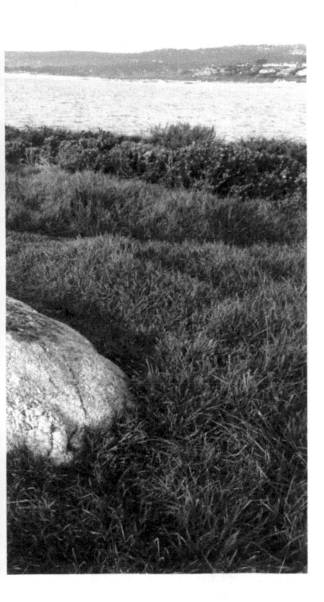

Sea Lion Point Area

North Point and Cypress Cove (4)

GPS coordinates: 36°31'8" N, 121°56'59" W

As you drive from Whalers Cove, turn right on the park's main road and continue on to Point Lobos's main parking lot at Sea Lion Cove. This lot is adjacent to the reserve's Information

Cypress in evening light

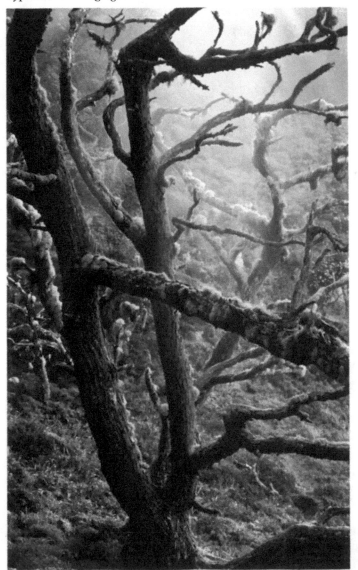

Station, which is staffed by docents from 9 AM to 4 PM. There are several trails from this parking lot, including one that goes west called Sea Lion Point Trail. Instead of heading west, walk past the small information building to a point where the trail divides; both walks provide good locations for photography. One trail you should not miss is the one to the left—the Cypress Grove Trail, which circles the Allan

Old Veteran's Tree

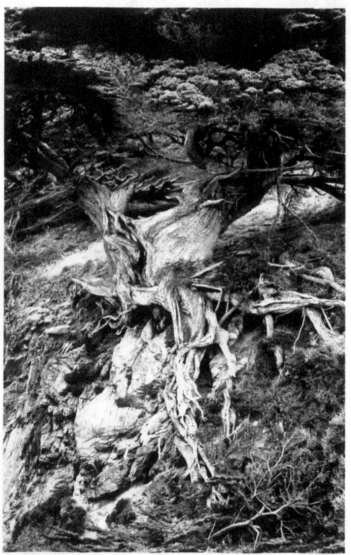

Memorial Grove. This grove is home to one of two natural stands of Monterey cypress trees in the world. Directly exposed to the elements—wind and salt spray—the trees have a fantastical, ghostly appearance. Their dramatic limbs, often covered with moss, are a must for photographers.

As you continue along the trail and climb a short hill around a small bluff, there are several good locations looking north along the coastline. As you proceed farther along the trail, you will soon come to a small grove of trees that are covered in a reddish algae called trentepohlia. The orange-red color is caused by carotene; the algae does not harm the trees. Try to be at this location as the sun is setting—the warm horizontal light accentuates the color of the algae in the gnarled tree limbs. I also like to photograph the nearby cypress trees, which have white Spanish moss hanging from their branches. These ghostly trees make excellent subjects for black-and-white photography. Continue along the Cypress Grove Trail, as it is a short loop that leads back to the parking lot.

Old Veteran's Tree (5)

Follow the same trail past the Information Center, but this time when it splits take the trail to the right, which becomes the North Shore Trail. A short distance from the parking lot the trail forks to the left, leading to the Old Veteran's Tree. This tree clings to a hillside across a small canyon, and its exposed roots and canopy make for a striking image. There are two small places to stand along the trail offering fine vantage points from which to view and photograph this well-known tree. The Old Veteran's Tree is best photographed on a cloudy or foggy day when the light is soft and the contrast caused by direct sunlight is minimized. Be sure to take both vertical and horizontal shots so you can include both the canopy and the roots in your image.

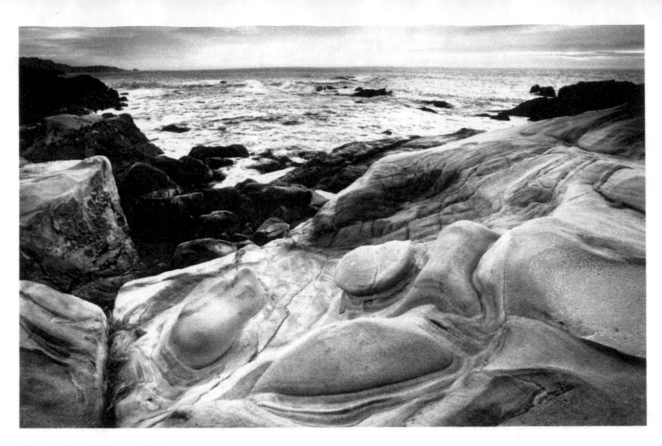

Sunset, Point Lobos south shore

South Shore Area

Turnout Across from Piney Woods (6)

GPS coordinates: 36°30'55" N, 121°56'53" W

As you leave the reserve's main parking lot and continue south along the coast, there are three small turnouts along the ocean side of the main road offering great views. There is also a trail running parallel to the road, but when photographing I prefer to drive and stop at the turnouts, so that my camera gear is nearby in the car. From each of these three locations you can view sedimentary rock with striking patterns, interesting embedded rocks, and unusual geologic formations.

Although all of these turnouts have much to offer, the second, directly across from Piney Woods, offers the most unusual rock formations and is my favorite. If time is limited and

you can't visit all three turnouts, I suggest you stop here first.

To take close-up shots of these rocks, I often use a macro lens or a lens with a shorter focal length, such as a 50mm. Try to avoid shooting in full sun, as the light on the rocks creates too much contrast with the highlights and dark shadows. In fact, a rainy or cloudy day at Point Lobos is the perfect time to photograph these formations. There's so much here to see and to photograph, it's tempting to start snapping away as soon as you arrive. Take the time to walk around this area and explore before you begin shooting. Look for interesting patterns in the multicolored rocks near the tide line and small vignettes or compositions.

A little farther south of the turnout across from Piney Woods is a tiny cove called the Slot. At low tide you can photograph this small

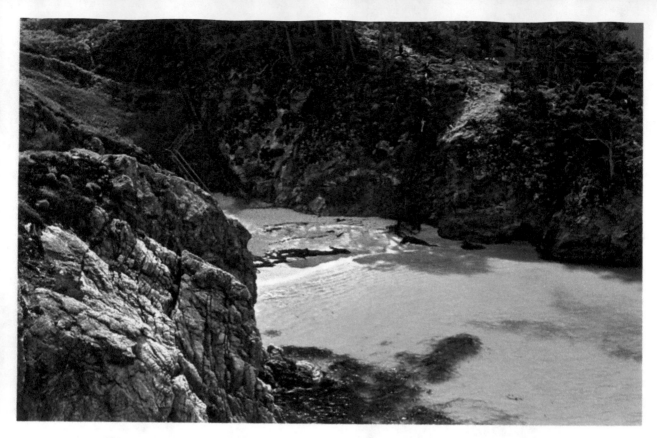

China Cove

rocky beach, where you'll find stones with interesting patterns. The kelp that washes ashore here also makes for an interesting subject.

Weston Beach (7)
GPS coordinates: 36°30'47" N, 121°56'36" W

The south shore of Point Lobos is a great location for tide pools, especially around Weston Beach. If you happen to be in the reserve during a low tide, it is easy to find colorful starfish and green sea anemones in the shallow pools left by the retreating ocean. Be very careful, however, as rocks covered with seaweed or kelp can be very slippery. Also, watch the waves, especially if the tide is rising!

Weston Beach is named for the well-known Carmel photographer Edward Weston, who lived near Point Lobos on the eastern side of Highway 1 up Wildcat Canyon. There are

some interesting eroded rock formations at the south end of this beach that take a diagonal path toward the ocean. The rocks have a warm, red color and have interesting cracks and linear elements that lead the eye to the ocean. This is a great location for sunsets at Point Lobos, particularly if there are clouds in the sky. I prefer to use a wide-angle lens such as a 20mm to include the rocks in the near foreground and often employ a neutral-density filter to even out the tonality between the bright sky and the dark foreground. When you are photographing images like this, try watching the waves for a while and see how the water is moving across the rocks. The motion of the water can become a major element in the final image, so it is something to consider when photographing along the coast. I have found that receding waves or the receding motion of

water often enhances the image more than incoming waves.

China Cove (8)

GPS coordinates: 36°30'34" N, 121°56'29" W

There is a parking lot at the end of the main road in Point Lobos with picnic tables and restrooms just before China Cove. From this parking lot the trail heads south and climbs slightly to an excellent view of China Cove below. There are times of the year when the white sand under China Cove turns the water a brilliant turquoise color that is reminiscent of the Caribbean. Aside from the view on the hill above as you approach China Cove, there are also good images down on the beach, which is accessed by walking down the long stairway to the sand. Be sure to bring a circular polarizer to remove the glare from the water and enhance its bright blue color. I have also taken some nice shots of China Cove from the other side, from the loop trail that leads out to Bird Island.

Bird Island (9)

The trail past China Cove leads either down a set of stairs to Gibson Beach or continues in a loop from which Bird Island is visible. I have always enjoyed photographing Bird Island, especially in the spring. It is a large, barren rock outcropping with a large colony of Brandt's cormorants. These birds make their nests on the ground in the spring and the males perform elaborate mating dances. Their breeding plumage consists of bright blue feathers, which are visible as the males stick their tails in the air and extend their wings to attract females. Be sure to bring a telephoto lens to get better shots of the cormorants, but wider views of the entire island also make for a strong image, especially on cloudy or foggy days.

Cormorants on Bird Island

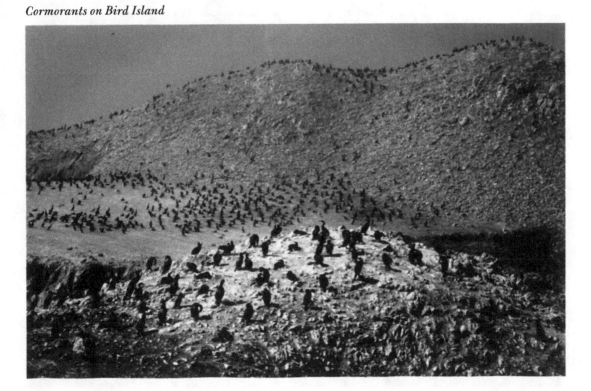

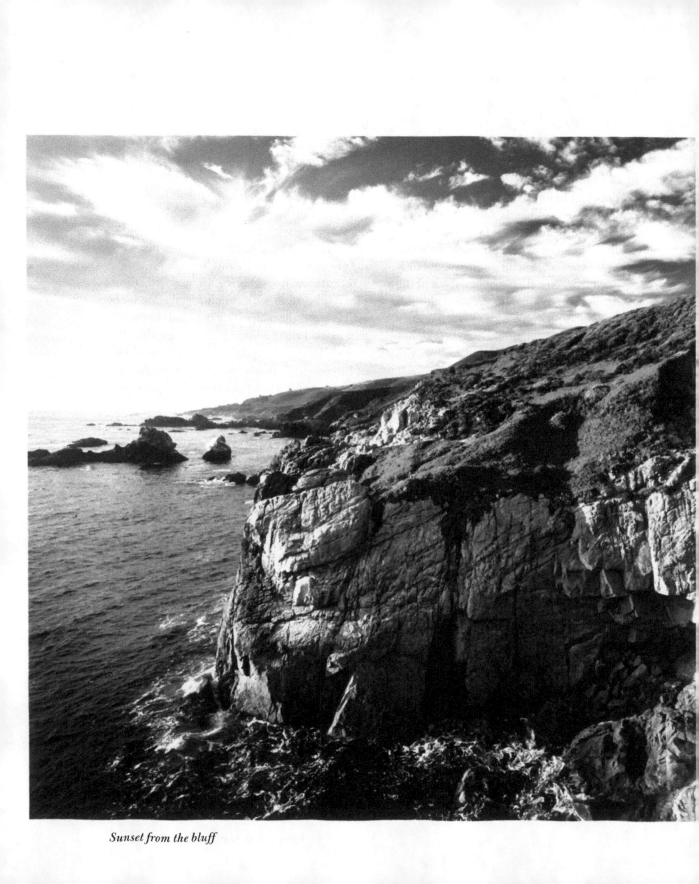

Sunset from the bluff

II. North Coast of Big Sur

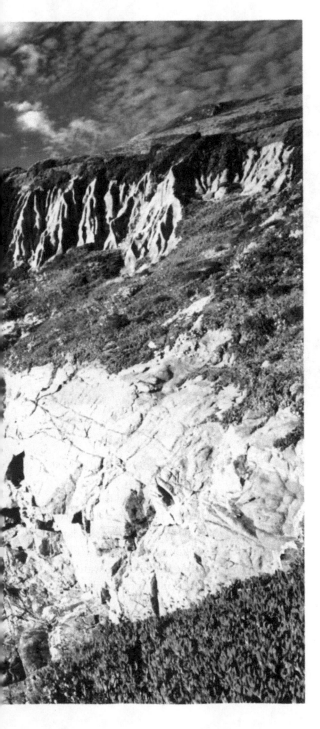

Garrapata State Park, First Turnout (10)

Between mile markers 66 and 67;
GPS coordinates: 36°28'17" N, 121°56'5" W

As you drive south along Highway 1 from Carmel you pass through the Carmel Highlands, a heavily wooded area that once was home to Edward Weston and Ansel Adams. Shortly after the roadway crosses Mal Paso Creek, the trees give way to open hillsides covered with chaparral, and the Pacific Ocean becomes clearly visible. This is the beginning of the Big Sur coastline. A small sign tells you that you are entering Garrapata State Park, which extends along the coastline for about 3 miles. Included in this park area are many scenic turnouts including Soberanes Cove, Soberanes Point, and Garrapata Beach, which is located at the southern end of the park. As you enter the park, there are a couple of turnouts on the right side of the highway that have paths leading down to the rocky shoreline. This first turnout is a good location for photography, allowing you to include rock formations in the foreground of your image along with the ocean and, possibly, dramatic clouds in the sky.

From the pullout along Highway 1, walk down the stairs and follow the path to the ocean. If you turn right, or north, the trail leads down to a rocky ledge below. There are some impressive rock formations as you approach the ocean, but there is no beach, and getting close to the water is difficult at this location. But this is a good spot when the sky is overcast or cloudy, particularly in the late afternoon or at sunset.

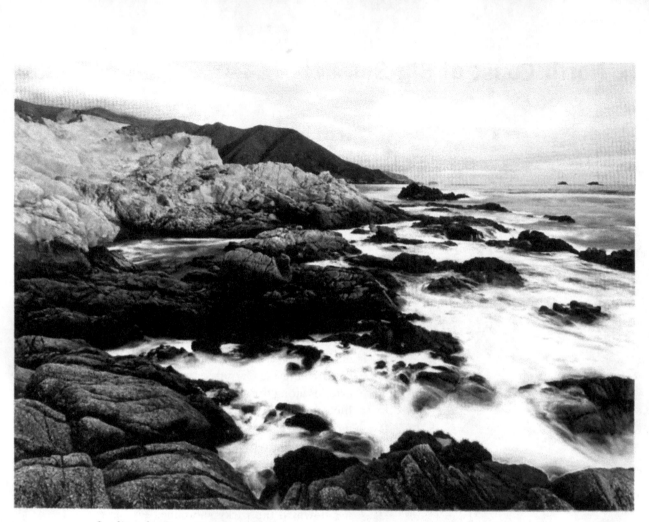

Sunlit rocks, Garrapata State Park

Garrapata State Park, Second Turnout (11)

Near mile marker 67;
GPS coordinates: 36°28'11" N, 121°56'60" W

The second Garrapata State Park turnout is located just north of mile marker 67. A rock outcropping with a small notched peak located about 100 yards offshore will help identify this location. I have photographed in this area many times and always find something different and striking, especially just before and after sunset. As you go down the stairs toward the ocean, bear to the right and then take the first path leading down to the water. There is a large cove that runs in a diagonal direction to the shoreline; I prefer to stay to the north of the cove for better access to the water. If you look down you will notice that you are walking across a large Indian midden of broken abalone shells. There are several paths leading down to the water and I always find interesting photographs along this shoreline, especially in the late afternoon or at sunset. This is a particularly good location to photograph with a slow exposure speed, as the waves hit the rocks and stream down in small waterfalls. These shots convert very well to black and white.

Eroded Cliffs along Highway 1 (12)

GPS coordinates: 36°27'34" N, 121°55'29" W

The stretch of Highway 1 just north of Soberanes Cove is interesting for the eroded cliffs lining both sides of the highway. Although similar cliffs can be found along Highway 1 in other locations farther south, these particular walls are the most dramatic and photogenic, in my opinion. There is a shoulder on the ocean side of the highway, but I prefer to pull off at the turnout to the north of the cliffs on the eastern side of the road. Be very mindful of the passing traffic at either location.

Try to avoid photographing the cliffs in direct sunlight, as this generates too much contrast between the bright areas and the darker shadows. I prefer to photograph these cliffs on cloudy or overcast days, or just after the sun has set, to optimize the interesting linear patterns created by the erosion.

Turnout at North Soberanes (13)

Mile marker 66 (turnout);
GPS coordinates: 36°27'24" N, 121°55'27" W

The turnout at mile marker 66 is one of my favorite locations for photography along the Big Sur coast and is located just north of Soberanes Creek, which flows from Soberanes

Cliff face along Highway 1

Canyon to the east, traveling under the road and ending at a small rocky beach. I have labeled this spot North Soberanes because the larger parking areas for Soberanes Cove and Soberanes Point are about 100 yards to the south. There are three great areas to photograph while parked at this area. First, there is a small rocky beach where the creek flows into the ocean. Second, there is a small overlook at the end of the main trail (if you don't cut down to the beach) with great views both to the north and south. Third, you can turn and walk north along the top of a series of cliffs or high bluffs that offer a variety of locations for photographing both the ocean and the eroded coastline.

Rocky Beach at North Soberanes (14)

From the turnout at mile marker 66 you will notice two trails—a main trail leading to the ocean, and a smaller diagonal trail leading across the vegetation to the cliffs and bluffs. To get to the small rocky beach, follow the main trail until the beach comes into view on your left (to the south). To get down to the beach you must descend a narrow, perilous trail to the left facing the ocean. This trail is steep and slippery but the view from the beach is well worth the effort, so take your time and be careful! Another option is to take the trail down to

View from bluff north of Soberanes Creek

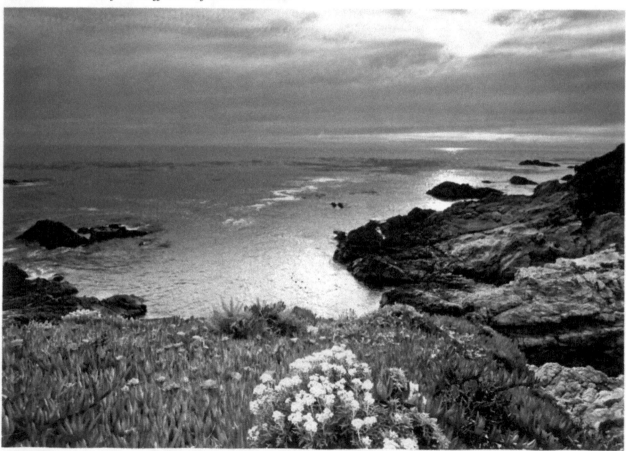

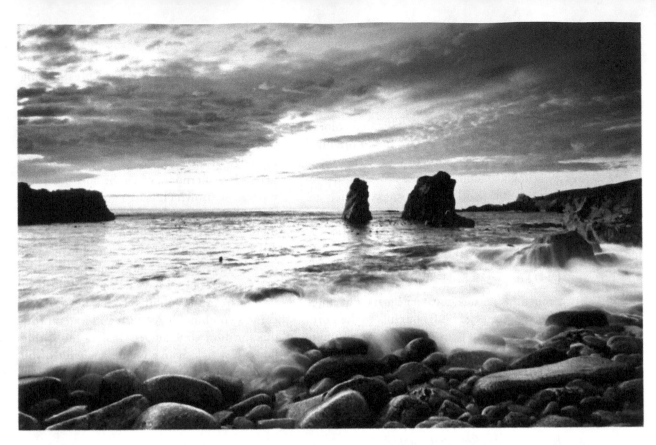

Sea stacks at sunset

the creek near the waterfall, but this way is even more challenging and I don't recommend it.

Once you are down on the beach, the smooth round rocks make a great foreground for the two large sea stacks that you will see directly in front of you. Sea stacks, which are freestanding columns of rock formed by erosion, are a recurring feature of the Big Sur coastline and make great photographic subjects, especially when they are sidelit in the late afternoon. This is an excellent sunset location, and it is even better when there are clouds in the sky. I recommend using a wide-angle lens, positioning the large round rocks in the foreground and including as much of the background as possible. Once you are set up, take note of the wave action; in my experience a receding wave usually yields the best images. Photographers frequent this location, but the

lighting, tides, and wave movement are different every day and you can always find an interesting way of photographing the scene. I generally avoid the beach at low tide, because the exposed rocks are covered with seaweed and are too dark. Also, when the tide is very high, the rocks can be under water.

Overlook at North Soberanes (15)

There is a nice promontory at the end of the main trail that has a panoramic view of the Pacific Ocean and the Big Sur coastline. If you follow the same path that leads to the rocky beach but stay straight instead of going down to the beach, it will lead all the way to the ocean to this striking vantage point. The ledge is small and there is only room for one photographer at

a time, but this is a particularly good location in the late afternoon before the sun sets. As the low, setting sun moves toward the horizon, the bluffs to the north turn a rich golden color in the sidelight. Be sure to take both horizontal and vertical images from this location, using a wide-angle to midrange lens. You can also photograph the two large sea stacks, which are right in front of you at this overlook.

The Bluffs at North Soberanes (16)

From the same turnout at mile marker 66, there is a large series of bluffs or cliffs to the north overlooking the ocean. You can reach these bluffs by following the second path from the parking lot, which cuts diagonally across the vegetation toward the water. This path will lead you out to a small trail that runs parallel along the ocean for one of the most breathtaking views along the Big Sur coast. There are several excellent locations from which to photograph the steep and rugged coastline, and you will discover them as you walk north along the top edge of the cliff. My favorite time of day here is late afternoon, when the horizontal sun warms the brown cliffs to a golden color and the red ice plant is well lit. If you are lucky there will be clouds in the background, but if not, minimize the sky in the image and concentrate on the waves crashing against the rugged and eroded rocks. I have taken many striking images from these bluffs, facing north to include a combination of cliffs and water. From this location you can get close to the spring flowers, which, using a wide-angle lens, you can use as foreground, with the cliffs as middle ground, and the clouds and receding coastline as background.

Receding wave, Garrapata State Park

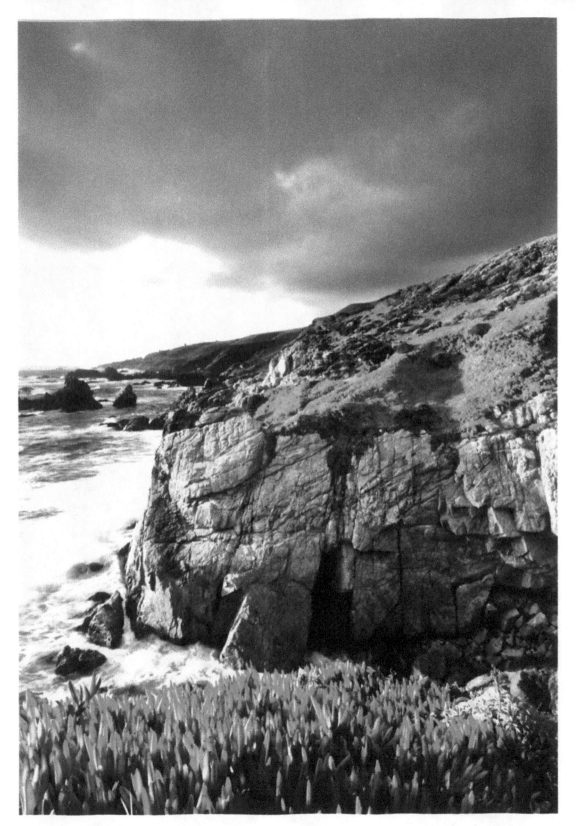

Coastline in light afternoon sun

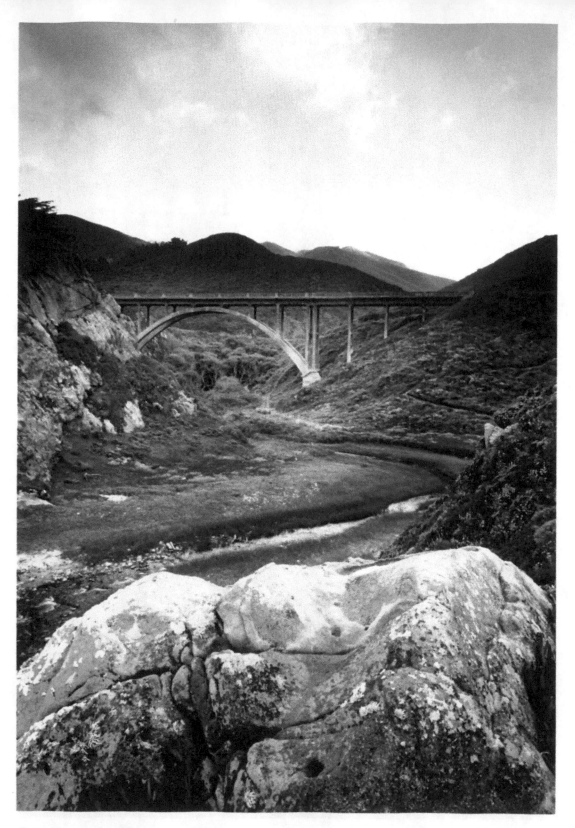

Garrapata Creek Bridge

III. Soberanes, Garrapata Beach, and South to Rocky Creek Bridge

Soberanes: Main Pullout South of Soberanes Creek (17)

South of mile marker 66;
GPS coordinates: 36°27'16" N, 121°55'27" W

The Soberanes area is easily identified by the large grove of cypress trees along the east side of Highway 1 and the rust-colored barn that sits on a hill above the highway. This is a very popular hiking spot, and there are several areas to turn out and park along the highway. If you want to take the hike, follow the trail from the main pullout to the east as it meanders along Soberanes Creek through a redwood grove. After a mile or so it turns steeply uphill to a summit of 1,900 feet above sea level. If you are doing the loop in this counterclockwise direction you will be treated to great views of the Big Sur coastline as you descend. The Soberanes area on the ocean side of Highway 1, across the highway, is a favorite among local photographers because of the rugged shoreline and panoramic views. In the spring and early summer the terraces above the ocean are blanketed with wildflowers, which provide a colorful foreground to the weathered cliffs and blue water in the background.

The Bluffs at Soberanes (18)

The trail from the main pullout divides to the left and right. If you follow the trail to the right it will lead you to a high bluff overlooking the ocean with views of the many sea stacks below and the Pacific coastline receding to the north. As you follow the trail along the bluff, it will take a turn to the right as it nears the ocean. There is a small rocky peninsula along this trail, which

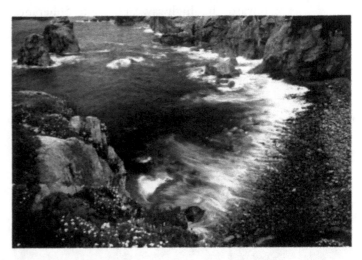

View from the bluff

is accessible and allows you to get closer to the water via a narrow, steep chute that is easier to navigate than it first appears. The chute leads down to bare rocks that are often occupied by fishermen, and the perspective here is markedly different from that on the bluffs above.

If you continue along this trail and do not go down the narrow chute to the peninsula, you will soon be above the same two large sea stacks that were visible from the parking area north of Soberanes Creek. These rock columns make strong images in the late afternoon, just before and after sunset when the light shifts from overhead to a warmer and softer sidelight. Be sure to photograph them from a location that allows for some separation between the two stacks, otherwise they will blend together and look like one large rock. If the waves are rough, this is an excellent spot to take images of the water splashing high into the air as it hits the vertical sea stacks.

Soberanes Creek Waterfall (19)

If you follow the same trail that goes along the top of the bluff a little farther it will turn back toward the highway, and soon Soberanes Creek and the waterfall below will come into view. This location, along the south side of Soberanes Creek, offers the best view of the waterfall, which is at its fullest during the win-

Waterfall on Soberanes Creek

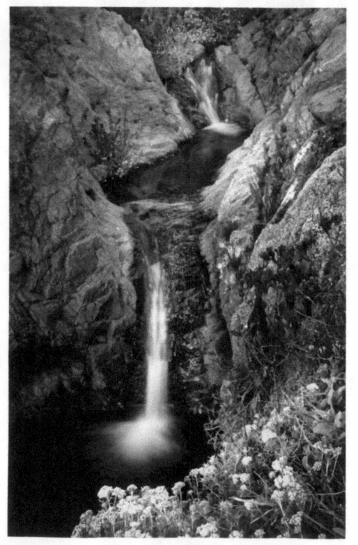

ter rainy season. You will need a small telephoto lens such as a 200–300mm in order to have the waterfall fill the frame, but there are other shots with wider-angle lenses. With a wide-angle lens you can include the colorful flowers growing here during the spring and early summer; they make an interesting foreground, with the waterfall and creek in the background. After you have photographed the main waterfall, walk a little farther upstream to see the smaller ones along the creek.

Soberanes Trail to the South (20)

Park your car in one of the large pullouts near the main entrance to Soberanes, and this time follow the trail to the left, which will take you through a grove of cypress trees onto a wide-open terrace above the ocean. Across the top of this broad plateau there are many opportunities for sweeping views to the north, and in the late winter, spring, and early summer there are a variety of yellow wildflowers—yellow lupine and mustard. A short distance beyond the trees there is a small trail to the right, which dead-ends on a high bluff with dramatic views of Soberanes Cove to the north. The best time to visit and photograph this area is about an hour before sunset, when the sunlight is horizontal and the rocks in the cove turn a golden brown. If you are lucky enough to have clouds in the sky, they will make the image even stronger.

Beach at Soberanes (21)

As you backtrack to the main path and continue on the trail going south, you will see a set of old redwood stairs, which lead over a small rise onto a second large plateau. The trail goes around the edge of this large flat area and eventually behind the distinct cone-shaped hill to the east and back to the parking area. Stop at the top of the stairs and look back to the north

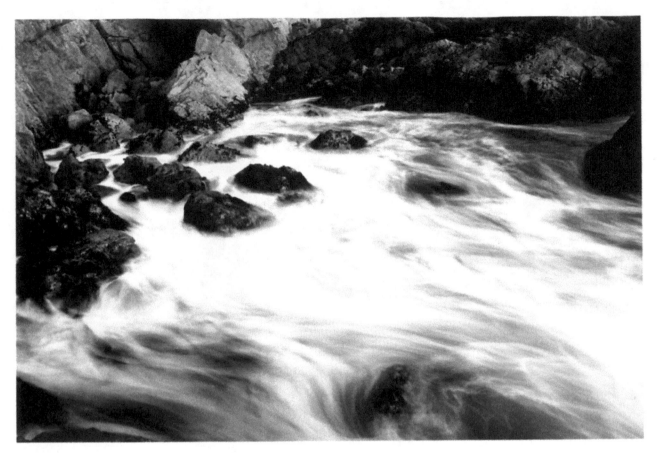

Receding wave and sunlit rocks

for another sweeping coastline view. This is a great location in the spring and early summer, when the many wildflowers turn the landscape into a yellow sea of color. With a wide-angle lens, you can photograph the sweeping coastline with the flowers in the foreground and the deep blue of the Pacific Ocean in the background. As you continue along the trail you will come upon a fork to the right that heads down to the ocean and a small beach, which is a nice location for photography if you want to get close to the water. After leaving the beach you can continue along the same trail, which will loop around the tall cone-shaped hill, or you can backtrack to the parking area.

View of Soberanes Cove (22)

Between mile markers 65 and 66

Driving south from the main Soberanes pull-out, go about 0.25 mile up the hill, where there are two small turnouts on either side of the highway. These pullouts are very small and will accommodate only one or two cars at a time. They are also easy to miss if you're not careful. Both offer spectacular views of Soberanes Cove to the north. There are many sea stacks protruding from the water and they help make this an excellent shot with a wide-angle lens. In the spring and winter the hillsides are covered with bright yellow lupines and yellow mustard, which add another dimension to this location.

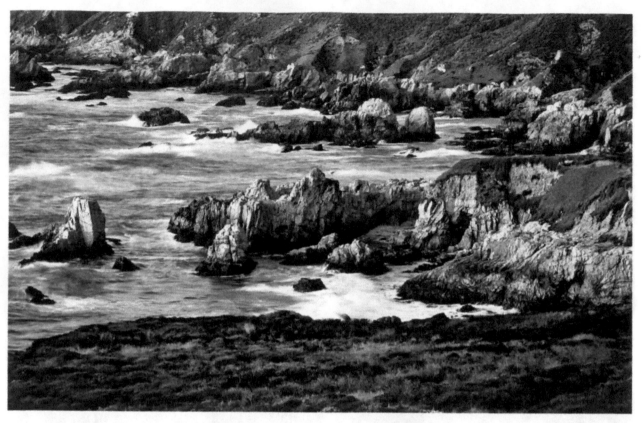

Evening at Soberanes Cove

A trail from this turnout leads down to the network of trails that weave throughout Soberanes, and the views get better as you walk a short distance down the trail. At sunset the sea stacks turn a rich, golden brown color and this is definitely the best time of day to be in this location.

Overlook South of Soberanes (23)

Mile marker 65;
GPS coordinates: 36°25'52" N, 121°55'33" W

Just south of Soberanes Cove at mile marker 65 is a turnout where the path leads to a large redwood bench overlooking the Pacific Ocean. If you're looking for a romantic spot to enjoy the

sunset with a special someone, this is it. This is not a particularly good location for photography, but the views and sense of being alone with the ocean make it very appealing. In addition to the sweeping views from the bench, there are a couple of steep trails that lead down to the ocean and to a small, sandy beach to the north.

North of Garrapata Beach (24)

Mile marker 63.6;
GPS coordinates: 36°25'22" N, 121°54'45" W

This turnout is a little difficult to locate, so watch the mile markers carefully. Driving south along Highway 1, the pullout is just north of a culvert with a guardrail on the ocean side of the

road with its own mile marker that reads 63.6. The large white sandy beach below the highway is Garrapata Beach. The Spaniards named the beach for the ticks that are ubiquitous along this coastline (*garrapata* is Spanish for "tick"). They probably also encountered poison oak, which grows abundantly along the hillsides and many trails. About 0.5 mile north of Garrapata Beach is the turnout described above, with a trail that leads to a bluff overlooking the beach. I think this view to the south of the sweeping coastline is the most photogenic one of Garrapata Beach. This site is best photographed with the sun low on the horizon, providing a soft, warm sidelight. I use a mid-range lens, about 50–70mm, to include the entire beach and some of the bluffs to the left. Because the bluffs are so much darker than the ocean and the beach, I recommend taking two exposures—one for the water and one for the bluffs—and blending them together in Photoshop. If you are not familiar with this process then be sure to include more of the beach and water and a smaller amount of the darker bluff, or vice versa. The idea is not to split the image so that half is bright and half is dark, because this makes it impossible for the camera's light meter to get a correct exposure. By emphasizing either the light beach or darker bluffs, the camera will give a better exposure.

View of Garrapata Beach

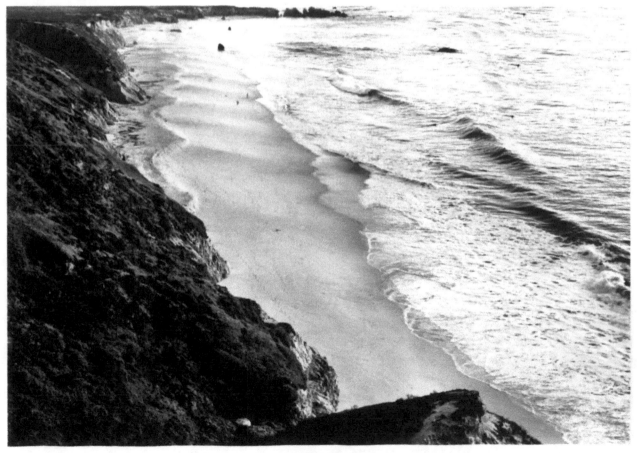

Garrapata Beach (25)

Mile marker 63;
GPS coordinates: 36°25'8" N, 121°54'48" W

The large turnout on the ocean side of the road above Garrapata Beach makes parking here easy. Garrapata is one of the most beautiful beaches along the Big Sur coastline and is also a favorite of many local photographers due to its close proximity to Monterey and the striking triangular-shaped stones that are found along the surf line. These stones are revealed in the surf at lower tides and their repeating geometric forms have been the subject of numerous photographs. But I don't want to discourage you from trying your own interpre-tation, especially if you arrive during a cloudy, moody late afternoon or evening. These stones also make strong subjects for black-and-white images. Aside from the stones, there are many interesting subjects to photograph at this beach, including the brownish bluff walls, which become more colorful in the late after-noon and evening light. There are also inter-esting perspectives from the high bluff above the beach. I have always enjoyed photograph-ing along this beach and highly recommend it as a destination.

If you are looking for a place where you can take your shoes off and walk along the surf line, Garrapata is the best beach in the Big Sur area north of Pfeiffer Beach.

Rocks at Garrapata Beach

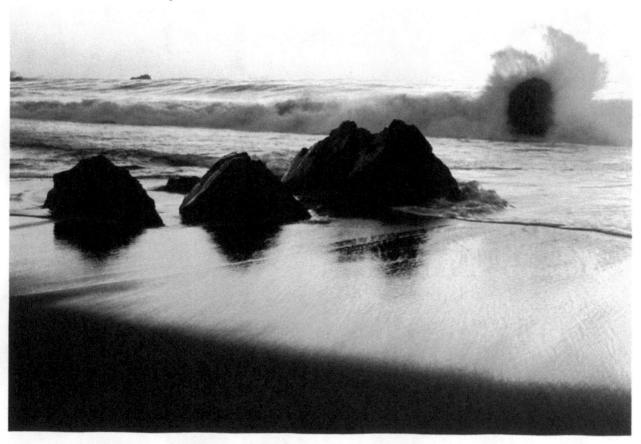

Calla Lilies along the Small Creek at Garrapata Beach (26)

At the north end of Garrapata Beach is a small creek that is bordered by calla lilies in the winter months of February and March. This creek used to be somewhat difficult to reach, but a few years ago state park workers installed two paths, one from the north and one from the south, along with a very civilized set of stairs leading down to it. The best vantage point from which to take this photograph is slightly upstream, so that the flowers follow the path of the creek to the ocean. This is a good location to use a wide-angle lens such as a 24mm and include some of the flowers in the foreground, with the rest tapering off into the distance. This creek with the calla lilies can be photographed either in the morning or evening. In the morning the flowers are lit by the sun as it rises behind you, but in the evening you are more likely to have a colorful sky as a backdrop. I would just avoid the middle of the day when the sun is overhead, which generates too much contrast in the image.

Garrapata Creek Bridge (27)

Mile marker 63;
GPS coordinates: 36°24'58" N, 121°54'51" W

Just south of Garrapata Beach is Garrapata Creek, which flows under the Garrapata Creek Bridge. The small turnout here is on the east side of the highway, so use caution when crossing Route 1. My favorite image from this location is the large rugged stone wall that rises up from the creek. This wall turns a rich brown color in the late afternoon sun, and, using a wide-angle lens, you can include the winding creek and colorful ice plant in the same frame. The creek is accessible by traversing down the steep hill to a path below. The view of the bridge from creek level is also an interesting

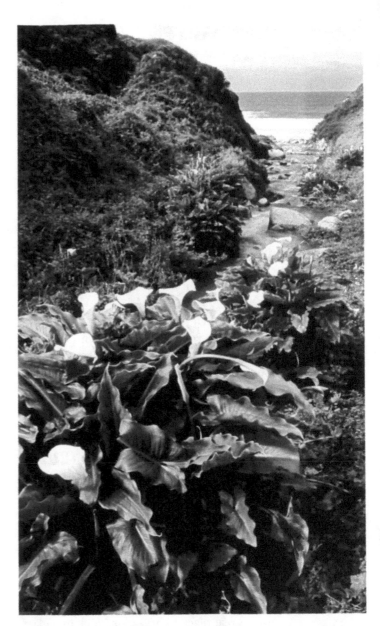

Calla lilies along the creek

perspective. One image that I like from this location is looking back at the sweeping arch of Garrapata Bridge. On the hillsides above the creek, some of the granite boulders contain Indian bedrock grinding mortars, as do many of the larger creeks along the Big Sur coast.

Paved Vista Point (28)

Between mile markers 61 and 62;
GPS coordinates: 36°24'41" N, 121°54'52" W

This turnout overlooks an interesting cove that can be photographed with a wide-angle lens. This is a location that shows better earlier in the day, because the setting sun seasonally casts a shadow over a portion of the cove, leaving part of it dark.

At the south end of the parking area there is a crude trail that leads down a steep hill and eventually winds around and drops down onto the beach. There are a couple of interesting locations from which to photograph as you follow this trail, but a large piece of concrete that presumably fell from the highway mars much of the view before you come to the beach.

The large rock outcroppings on the north end of the cove can be interesting subjects in rough surf, when the waves are high and crashing against them. Photographing from the turnout, you will need a small telephoto, such as a 200mm, to capture these crashing waves.

Rocky Point Restaurant (29)

Just south of mile marker 62;
GPS coordinates: 36°24'8" N, 121°54'42" W

Rocky Point Restaurant is impossible to miss, whether you are driving from the north or the south; there is a large sign next to the paved driveway, which turns west, toward the ocean. While there are some excellent locations for photography here, Rocky Point Restaurant is also a great place to break for lunch or a glass of wine. This restaurant is one of my favorite locations to share with out-of-town guests because it has sweeping views of the Big Sur coast that can be enjoyed in a comfortable environment. Also, a labyrinth of trails leads from the lower parking lot to various locations where it is possible to photograph the coastline to the south. If you follow the main trail that

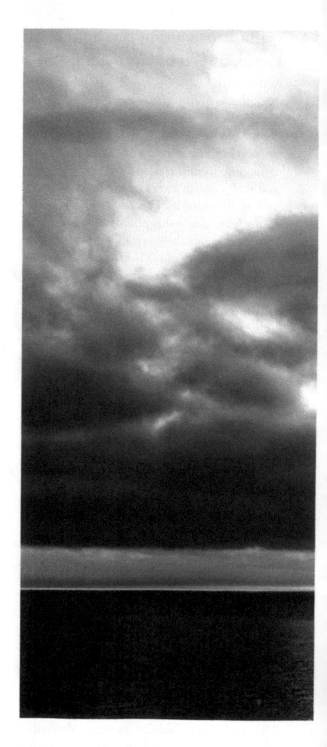

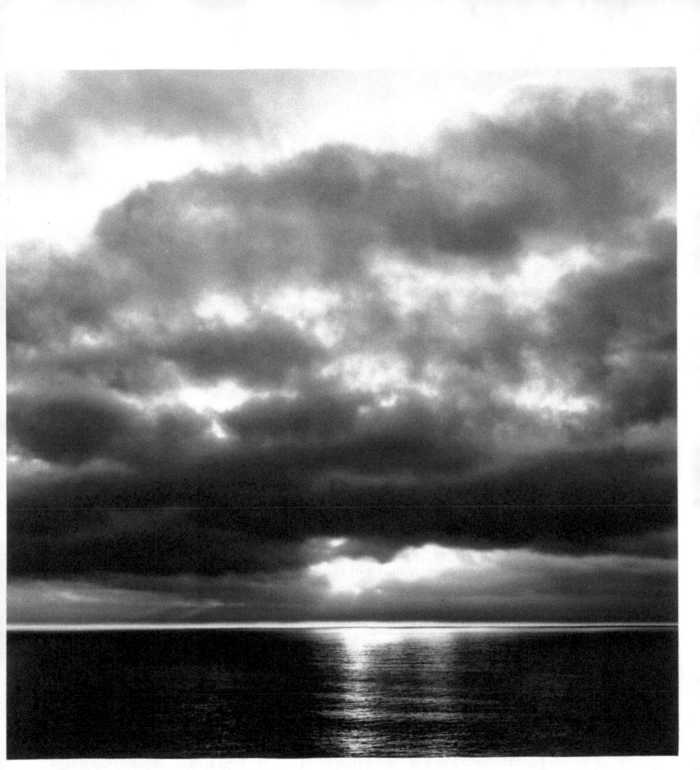

Clouds over the Pacific

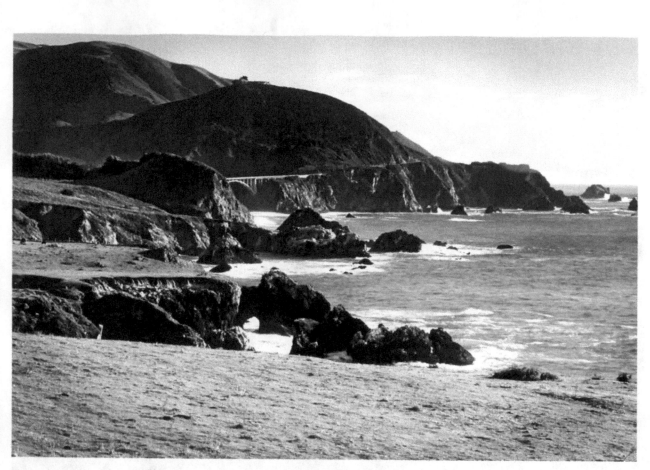

Rocky Creek Bridge scene

leads to the rock outcropping near the parking lot, it continues and drops lower and closer to the water, which is a better vantage point. I try to arrive here in the late afternoon to take advantage of the warm sunlight as it shines on the rocky bluffs below. This warm light contrasts nicely with the deep blue of the Pacific Ocean and the crashing waves. I have taken numerous images from various vantage points near this restaurant.

There is a large field to the south that turns green with the first winter rains and is frequently populated with a herd of cows. A large arch in the rocks is visible to the south, and Rocky Creek Bridge in the distance adds an-

other striking photographic subject. This is a location that should not be missed, especially during late afternoons in winter. This field can be photographed from the narrow driveway that leads down to the restaurant or from the turnout south of the restaurant, which is described below.

Turnout South of Rocky Point Restaurant (30)

GPS coordinates: 36°21'50" N, 121°54'24" W

There is a large turnout on the ocean side of Highway 1 about 100 yards south of the entrance to Rocky Point Restaurant. The view to

the south is a classic Big Sur image, especially in the winter when the grass is green. Note the striking arch in the rocks above the beach, and Rocky Creek Bridge in the background. In framing this shot, be careful that you don't cut off the top of the hill on the horizon. You can walk up and down this turnout and take photographs from several different locations offering good views. If you come at the right time, you might even be able to include grazing cows in your foreground. I have taken this scene with a variety of lenses, from a wide-angle up to a 200mm lens. The advantage of a wide-angle is that it is easier to keep everything in sharp focus, whereas with a longer lens you have to be more selective and not include so much of the foregound.

Palo Colorado Road (31)

Between mile markers 61 and 62;
GPS coordinates: 36°23'58" N, 121°54'16" W

Just south of Rocky Point Restaurant is a left turn onto Palo Colorado Road. The area surrounding this narrow, winding road was an important source of redwood timber in the early twentieth century. The shaded, cool feeling under the new-growth redwood canopy is totally different from the experience of driving along Highway 1. This is the best place to see and photograph redwoods north of Pfeiffer State Park in Big Sur. One of the best locations is about 0.25 mile or less up Palo Colorado, where the redwoods line a small creek. I also enjoy photographing the moss-covered old buildings that line the road.

One way to photograph the redwoods is to lie on your back and photograph upward with a wide-angle lens. When the original redwoods were cut, smaller trees often grew back in a circle around the original

stump. This circular pattern makes a strong image with the blue sky above. Be sure you do not underexpose the image, as the bright sky may cause the camera's meter to darken it.

On the ocean side of Highway 1, across from Palo Colorado Road and a little to the south, there used to be a small town, Notleys

Redwood canopy along Palo Colorado Road

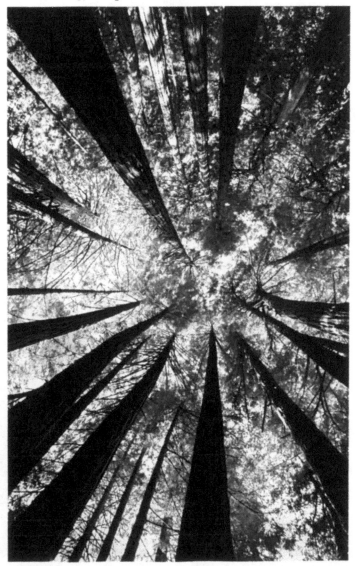

Landing, where lumber was loaded onto ships and taken to San Francisco. Tanbark oaks and redwoods were harvested and hoisted with cranes onto the waiting ships, and there was a well-known dance hall and saloon on the edge of the bluff overlooking the ocean. The concrete remains of the hoist and landing are visible today, just above the small cove to the south of the large green meadows along the highway.

Rocky Creek Bridge (32)

Mile marker 60;
GPS coordinates: 36°22'49" N, 121°54'7" W

From the large turnout at the north end of Rocky Creek Bridge on the ocean side, there are several locations to photograph both to the north and south. In my experience the best images can be found by walking toward the bridge to the end of the parking area and taking the path between the large rocks that leads down a slight incline toward the ocean and the creek below. I particularly like the image of the large sea stacks that rise out of the surf to the south. As you continue down this path you will also have a good view of the bridge behind you; this is an excellent location from which to photograph the bridge's open-spandrel arch with a wide-angle lens. I particularly like the bridge shots along the coast looking directly across at the arch, as the vertical members have a straight up-and-down appearance rather than seeming to lean in or out. As with many of the coastal shots in Big Sur, the best time to arrive is in the late afternoon, as the sun streams in from the side. One caution: be careful on the path, as the loose gravel can be slippery underfoot when dry.

Rocky Creek Bridge

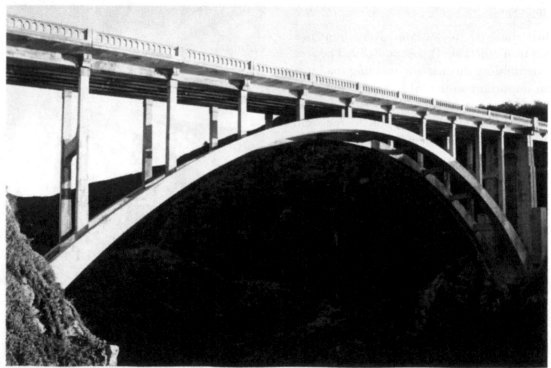

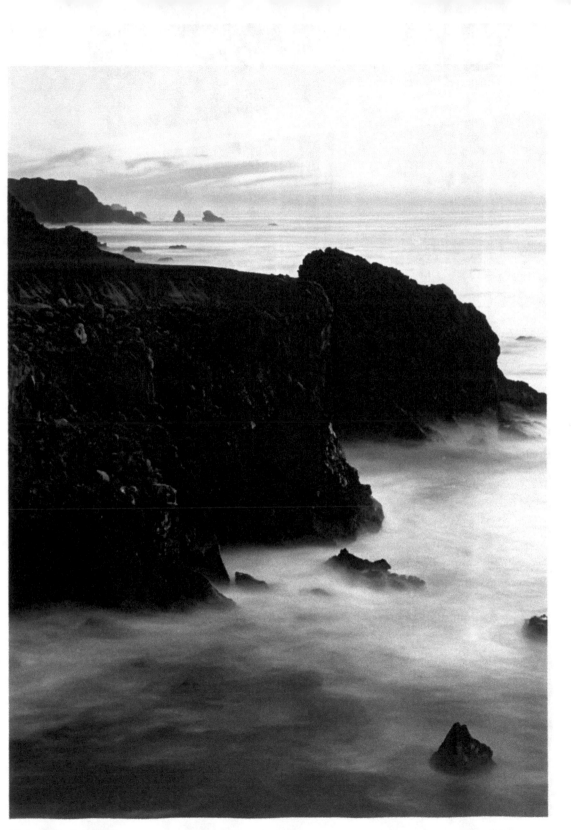

View of Big Sur bluffs

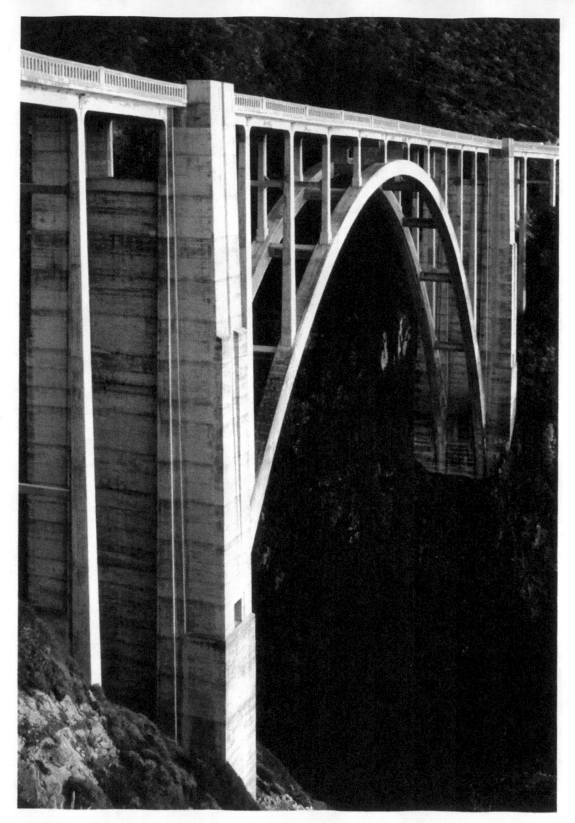

Bixby Bridge

IV. Bixby Creek Bridge Area

Bixby Creek Bridge

Mile marker 59;
GPS coordinates: 36°22'21" N, 121°54'10" W

The graceful curve of the span, striking center arch, and tall concrete supports extending down into the walls of the canyon make Bixby Bridge one of the most widely recognized and photographed bridges in the world. Constructed in the 1930s, the bridge is an amazing feat of engineering and aesthetic design. Construction of this bridge made it possible for traffic to continue south along the coast instead of driving inland along the Old Coast Road.

Bixby Creek Bridge from Below (33)

As you face the bridge from the parking lot on the ocean side of Highway 1, there is a small trail that heads down toward the creek. If you don't have a problem with heights, I recommend following this trail down until you are more or less looking straight across or slightly up at the bridge. This is a great vantage point from which to photograph the dramatic architecture of Bixby Creek Bridge, as the straight-on view allows the tall columns to appear vertical in your image, rather than leaning in or out. To achieve this perspective, find a location where the plane of the image sensor is parallel to the plane of the bridge so that the camera is not tilted up or down. When the bridge is photographed from above, which is the more common image, the columns appear to be narrower at the bottom than at the top; they taper.

Use a wide-angle lens and be sure to take both vertical and horizontal shots. This bridge photographs best from this angle when the sun is low on the horizon and the concrete has a warmer tonality. Another good time of day is early in the morning when the sun is just rising over the hills in the background and filters through the arches.

Bixby Creek Bridge with Foreground (34)

There are several other locations where you can photograph Bixby Creek Bridge, all within easy walking distance of the parking area. One interesting vantage point that offers a broader view of the bridge and some foreground can be accessed via a small trail that leaves the parking lot at its midsection and leads down about 100 feet to a small clearing. From here you can frame the entire bridge as a horizontal image, with the coastline fading away in the distance. While you'll need to watch your footing on this trail, the location is not as difficult to reach as it first appears, and this is a good location to photograph Bixby Creek Bridge and its environs.

Another good and unusual perspective of the bridge can be achieved by walking out on the bridge about 10 feet and, with a wide-angle lens, placing the curvilinear railing in the foreground as it sweeps to the south and up to Hurricane Point. Sometimes I put the camera right on top of the railing and other times I kneel down low to include the small arches that are a part of the railing design. These are both good images. Keep a careful eye on traffic if you attempt this shot because cars traveling from the north come around the bend quickly. If possible, have someone assist you by watching the traffic.

You can also get a good photograph from the end of the parking lot, where you can include the creek and beach below in your view of the bridge. This is the shot that most people take at this location, but it is still a very strong image. Be sure to use a wide-angle lens so you

can avoid pointing the camera down too much. Pointing the camera down will cause the vertical members to lean toward the center.

Bixby Creek Bridge from the Old Coast Road (35)

GPS coordinates: 36°22'22" N, 121°54'5" W

The Old Coast Road is the dirt road directly across from Bixby Creek Bridge. It heads inland and turns south into the Santa Lucia Range for about 14 miles before intersecting Highway 1 again across from the entrance to Andrew Molera State Park. Before Bixby Creek Bridge was completed in the early 1930s, this was the only route down to Big Sur from Monterey. There are a couple of locations for photography along the Old Coast Road, and these are easy to access from the road's northern and southern ends. But if you have time and decide to drive all the way up or down the Old Coast Road, you will find several interesting places to stop and photograph along the way, including redwood groves and panoramic views of the rolling hills at the southern end.

I prefer to photograph along the Old Coast Road in the winter months, when the moss on the trees and grass on the rolling hills are green. A sign at the entrance advises drivers that the Old Coast Road is impassable in winter, but I have never had a problem driving this

Bixby Bridge with foreground

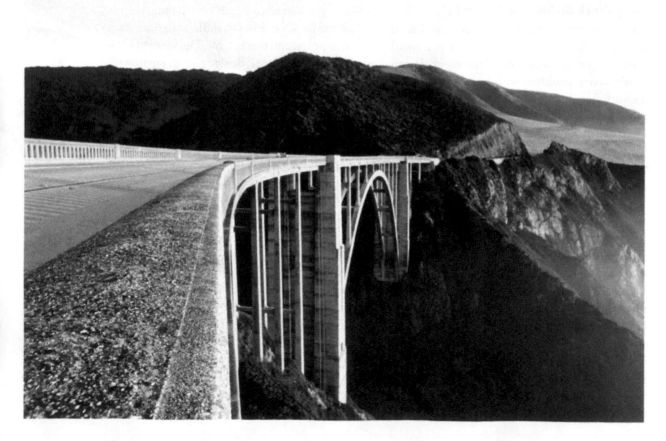

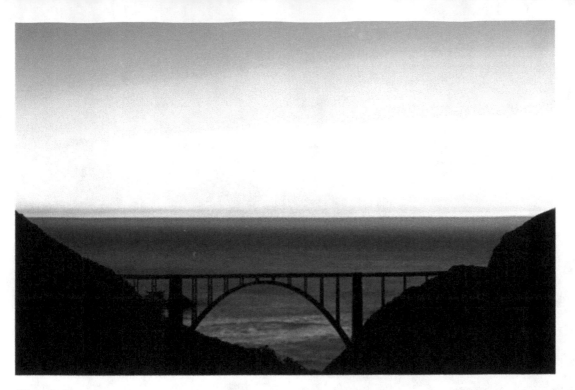

Bixby Bridge at sunset

road, even when it is wet. That said, it is probably a good idea to avoid this road after a heavy rain.

If you drive or walk up the Old Coast Road opposite Bixby Creek Bridge about a hundred feet, there are several vantage points that look back on the east side of the bridge. This is a favorite location for photographers during the Big Sur International Marathon, which crosses Bixby Bridge as the participants run from Big Sur in the south to Carmel in the north. This easy-to-reach location offers an expansive view of the coastline, with the curving bridge in the foreground. Early morning is the best time to be at this location with a wide-angle lens, because the sun rises to the east and lights up the inland side of the bridge. Various places along this stretch of the road provide unobstructed views of the bridge. You do not want to miss this location.

I have also photographed Bixby Creek Bridge from this location along the Old Coast Road using the full moon as a light source. The moon rises in the east and lights up the front of the bridge as well as the receding hills in the background. Photographing by moonlight requires a tripod, cable release, and longer exposures. The exposure time will depend on how late at night you take the image and how dark it has become. I often take three- to four-minute exposures to allow the softer moonlight enough time to brighten the scene. To take an exposure that is longer than thirty seconds, use the bulb setting on your camera, and if you have a long-exposure noise-reduction setting, be sure to use it. Moonlight photography may require a little trial and error, but the resulting tonalities are interesting and well worth the effort.

Sunset View of Bixby Creek Bridge (36)
GPS coordinates: 36°22'28" N, 121°53'46" W

If you continue driving up the Old Coast Road for 0.5 mile, it curves to the south, and there is a spot where you can pull over that offers an

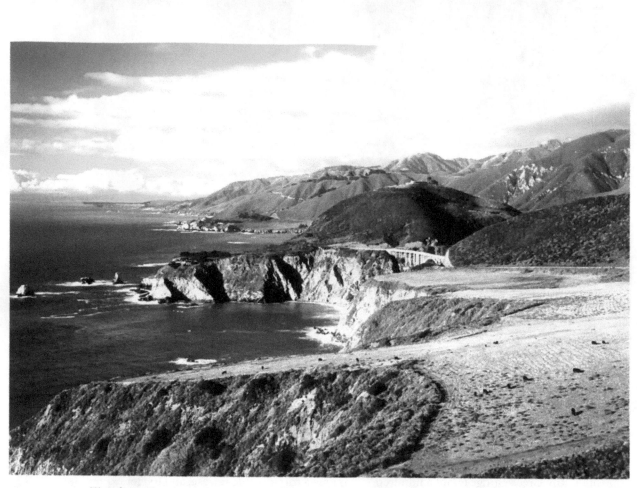

View from Hurricane Point

expansive view of Bixby Bridge. This is a particularly good location at sunset, as the bridge forms a silhouette against the evening sky. There are times of the year when you can frame the setting sun under the arch of the bridge, possibly with colorful clouds filling the frame.

From this point I recommend turning around and getting back on Highway 1 to continue the drive south, rather than staying on the Old Coast Road. Much of the land along the sides of this road is private property and not accessible to photographers. There are other interesting locations to photograph from the Old Coast Road, but they are easily reached from the road's southern entrance, across from Andrew Molera State Park.

View from Hurricane Point (37)

GPS coordinates: 36°21'26" N, 121°54'10" W

The view to the north from Hurricane Point is a classic Big Sur image, and it photographs well under most conditions. There are large fields in the foreground, with Bixby Bridge and a sweeping coastline in the background. The fields in the foreground were part of the Brazil Ranch, which became the Funt Ranch when it was purchased by Alan Funt of *Candid Camera*

fame. Several years ago this large property was purchased by the Big Sur Land Trust and The Nature Conservancy, which will preserve this open space forever. The Big Sur International Marathon course includes the challenging 800-foot climb up the hill to Hurricane Point from the Little Sur River to the south.

Hurricane Point is well-named: the winds on the point are often so cold and strong that it makes photographing from this location difficult. However, I have been here on many occasions when it was calm and warm. The best images are taken in late afternoon or evening light, but I have also gotten some nice shots on stormy and overcast days, when the weather imparts an interesting moodiness to the scene. When the late-afternoon sun lights up Bixby Creek Bridge, the bridge becomes an even stronger element in the image.

View of the Little Sur River (38)

South of mile marker 58;
GPS coordinates: 36°20'52" N, 121°53'46" W

Driving south from Hurricane Point past mile marker 58, you will cross a small bridge; the second turnout after the bridge offers an impressive view of the Little Sur River. You will have to walk a short way down the hill to clear

Where the Little Sur River meets the ocean; Point Sur is in the distance

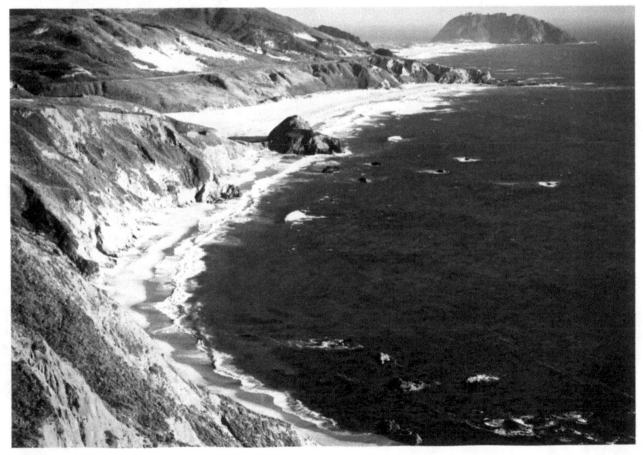

the foreground, but the view to the south where the river meets the ocean is dramatic. There is a large rock formation just at the mouth of the river, which adds an interesting visual element to the image.

Farther to the south is Point Sur, the large dome-shaped peninsula off the coast, with the Point Sur Lighthouse on the northern end. The coast curves in front of you, providing a nice combination of ocean and sandy, rocky shore. This is a location where you can photograph almost any time of the day, because the Pacific has a rich blue color when the sun shines through and reflects off the light-colored sand below. Good views of this location can also be found at the next couple of turnouts after this one.

Little Sur River Overlook (39)

GPS coordinates: 36°19'50" N, 121°54'31" W

There are two pullouts just south of where Highway 1 curves around the Little Sur River, easily identified by the large sand dune located on the east side of the highway. One of the pullouts is directly across from this sand dune and the second is about 100 yards north, down the hill and closer to the river. I always stop at these locations and frequently take photographs here because the conditions are always different. The Little Sur River forms a nice curve as it cuts across a large sandy beach and spills into the ocean. There is a large triangular rock promontory down on the beach, and the combination of elements including the sandy beach, the river, the rock, and the coastline to the north all contribute to an interesting composition. This location is unusual in that it can be photographed in the morning with the sun lighting the rock face, or in the late afternoon just before sunset. Be careful of the fence in the foreground; I usually move close to it so that it does not appear in my image. The property on both

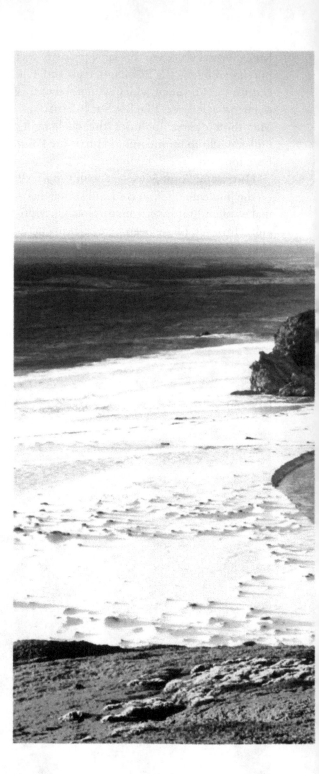

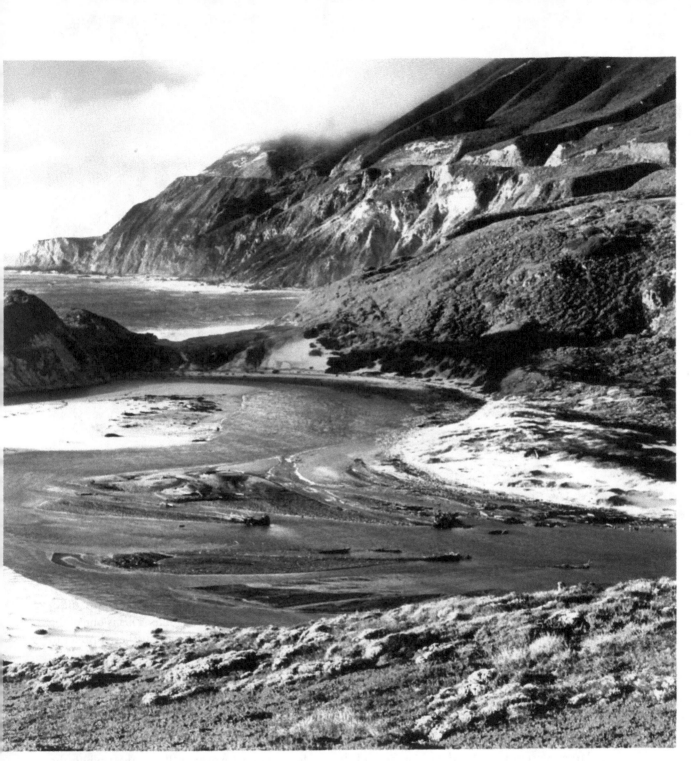

Little Sur River

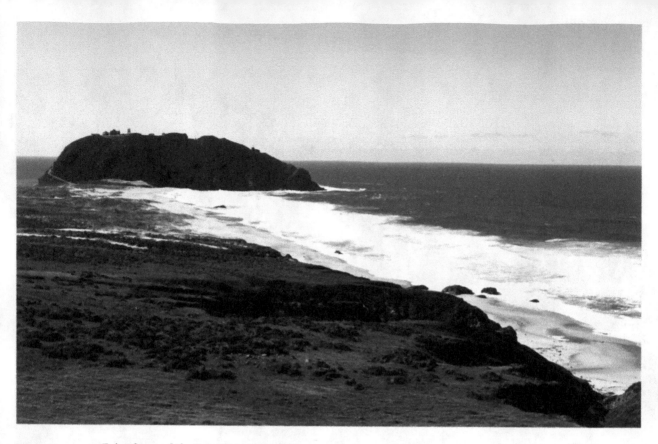

Point Sur and the Point Sur Lightstation

sides of the road from here down to Andrew Molera State Park is the El Sur Ranch, and trespassing on the ranch is prohibited, as is made clear by the numerous signs posted along the highway. The rolling pastures of the El Sur Ranch turn bright green in the winter months and the rolling hills and herds of cows there make for interesting images. I frequently see coyotes along this stretch of the highway as well.

View of Point Sur (40)

South of mile marker 55;
GPS coordinates: 36°18'60" N, 121°53'30" W

Just south of mile marker 55 and past all of the large cypress trees on the ocean side of the road, there is a large turnout on the west side. From this turnoff I suggest you walk back up the hill about 100 yards to have a better perspective on Point Sur and the long beach that leads to it. If you take the photo from the turnout, much of the beach will be excluded from the shot, and the beach is an important visual element that makes for a stronger image. From the right location this is a dramatic view of Point Sur, with the beach comprising a strong diagonal leading line. This is one of the few locations along the coast where I prefer to photograph in the morning, because the early sun lights up the front side of the Point Sur peninsula. The lighting is better in the summer as the sun moves farther north; in the winter the large peninsula with the lightstation is backlit so it often appears in silhouette. This location also works well at sunset when the contrast between the land and sky is not so strong.

Point Sur Lightstation (41)

GPS coordinates: 36°18'35" N, 121°53'10" W

There is a gated entrance to the Point Sur Lightstation off Highway 1, just east of Point Sur. Daytime and moonlight tours are available on a first come, first served basis (visit the Point Sur website or call for a schedule). This lighthouse was occupied from 1889 until 1974, and is now part of the Point Sur State Historic Park. Several of the buildings have been restored and the three-hour tours are on foot, led by a docent or volunteer. The lightstation is on the National Register of Historic Places, so if you enjoy visiting lighthouses, this one should be on your list.

www.pointsur.org
831-625-4419

Andrew Molera State Park—Cooper Cabin (42)

GPS coordinates: 36°17'19" N, 121°51'5" W

About 0.25 mile north of the main entrance to Andrew Molera State Park is a smaller entrance next to a large pullout on the west side of Highway 1. I prefer this entrance to the park because it has a more direct route to the ocean. A trail leads down to the Cooper Cabin, an old redwood cabin that was built in 1861 and has been well preserved. The Cooper Cabin is the oldest structure in Big Sur. It is located in the middle of a eucalyptus grove, which is a migratory winter stopover for monarch butterflies. If you like to photograph old, weathered buildings, this one is worth the time.

Originally this land was part of the Rancho El Sur, a Spanish land grant that was deeded to Juan Bautista Cooper. Cooper's grandson, Andrew Molera, established a dairy on the property and made Monterey Jack cheese. In 1965 Frances Molera donated this southern portion of the ranch to The Nature Conservancy in honor of his brother, and it was deeded to the California State Parks system in 1972. Andrew Molera State Park has added additional acreage through purchases and now comprises 4,785 acres along the Big Sur coast. There are a couple of excellent hiking trails in Andrew Molera State Park, which are located on the western side of the Big Sur River. It is easier to cross this river in the summer months when the water level is low. I often take the Ridge Trail south, which circles back to the Panorama Trail and becomes the Bluff Trail as it heads back to the park entrance.

Trail from Cooper Cabin to the Ocean and Headlands (43)

From Cooper Cabin there is a dirt road that leads from the main parking lot, past the cabin toward the ocean. Follow this dirt road for about 0.5 mile until it runs parallel to the Big Sur River. There is a turn to the right with a sign marked "Headlands Trail." Follow this trail up a set of stairs as it climbs to a high bluff above the confluence of the Big Sur River and the ocean. There are several interesting vantage points from the top of this bluff. You can look back down on the river as it forms a U shape and spills into the ocean or photograph the coastline to the north. Both are interesting perspectives to photograph with a wide-angle lens, and well worth the walk. If you continue along the Headlands Trail it leads to the top of the bluff, where there is a bench overlooking the river and the Pacific Ocean.

In summer this trail is often crowded with visitors, but during the colder winter months you will probably have the area to yourself. The river level is also higher in winter, which makes for a stronger photograph. The large triangular-shaped peak to the east, which dominates the landscape, is Pico Blanco, which rises to 3,709 feet.

Old Coast Road from Andrew Molera State Park (44)

Across from the main entrance to Andrew Molera State Park is the southern entrance to the Old Coast Road. This is the road that goes inland from Bixby Bridge to Andrew Molera and was the only north-to-south route before Bixby Bridge was completed in 1932. If you drive a mile or two up the Old Coast Road from Andrew Molera you'll find some great views to the north of the rolling hills and Highway 1 with the ocean in the background. The hills are particularly impressive in the winter and spring months, when they turn emerald green. I try to place something in the foreground of the large, sweeping landscapes—during winter and spring there are often bright-orange California poppies; in the absence of these try using a portion of the fence or large boulders. Having something in the foreground helps ground these images and gives the viewer an entry point.

The large triangular-shaped white mountain to the east is Pico Blanco. The peak is composed mainly of limestone and marble, which create the distinctive white coloration. Pico Blanco was considered sacred by the local Rumsien and Esselen Indians, who saw it as the source of life. An Indian legend has it

Big Sur River

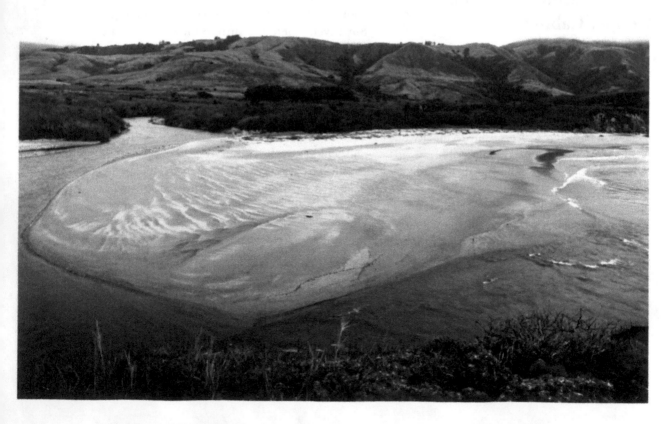

that the earth was once covered by a large flood, leaving only the summit of Pico Blanco above water. Several creatures on the summit survived the flood and went on to repopulate the planet. Sound familiar?

Pfeiffer Big Sur State Park (45)

GPS coordinates: 36°1'58" N, 121°53'29" W

The large redwoods alongside the road at the entrance to this state park make fine subjects for photography. The redwoods thereafter give way to oaks, pines, sycamores, and other trees. If you only want to photograph the redwoods, you can avoid paying the park entry fee by parking on the shoulder of Highway 1 across from the park and walking in.

A popular short hike in Pfeiffer Big Sur State Park is the Pfeiffer Falls Trail, which also passes through redwood groves. As you enter the park, take the road to the right, which leads to the Big Sur Lodge (see "Recommendations in Big Sur"), and look for a road to the northeast heading up a hill. Follow this road up to a fork, turn right, and drive into the parking lot, where you will see the trailhead for Pfeiffer Falls. The path crosses the creek a few times before arriving at two sets of stairs, which will lead up to the 60-foot Lower Falls. The Upper Falls is about the same height but is more difficult to photograph due to the trees blocking the view.

Pfeiffer Beach (46)

Between mile markers 45 and 46; GPS coordinates: 36°14'24" N, 121°46'38" W (turnout); 36°14'25" N, 121°46'38" W (parking area)

Pfeiffer Beach has become a well-known destination for photographers due to the arch formations in the rock outcroppings here. For just a few evenings around the time of winter sol-stice, when the sun is farthest to the south, these arches light up as the setting sun shines through them, lending a golden glow to the spray and the interiors of the arches. The resulting images can be stunning. This is the image that is on the cover of my first book, *Pacific Light*.

The road to Pfeiffer Beach can be difficult to find, because it is marked on Highway 1 only by a yellow sign indicating a turnoff at mile marker 45.64. Once you make this sharp turn off the highway, in about 0.25 mile you will come to a large stone wall with a sign that says "Pfeiffer Beach Two Miles." Continue down the road through the beach entrance and into the large parking lot. There are restrooms here, and a path that leads from the parking lot through a grove of trees and onto the beach. Once on the beach, if you stay to the right of the creek you will see the arches. The large arch off to the right is the one most frequently photographed, but there is a smaller arch almost straight ahead that also makes for a good subject. If you visit during the winter solstice, shortly before and after December 21, I suggest arriving about an hour before sunset to claim a good location, since this area has become very popular with photographers. Sunset in the winter is around 5 PM, and the best light is about 20 minutes before sunset.

The best time to photograph at Pfeiffer Beach is when the tide is ebbing or low, since this allows you to include the beach's large rocks and red seaweed in the foreground. The classic image of the lit arch requires a clear sky, as clouds or a fog bank can obscure the setting sun. But don't be discouraged if the evening is not as clear as you were hoping for. I have seen strong images taken at Pfeiffer Beach when the sun was behind a fog bank. This actually makes the exposure somewhat easier, because the lighting is more balanced, but it does eliminate the fiery light emanating from the arch.

If you do have good conditions and can photograph the golden light coming through the arches, pay attention to your exposure. The bright sun coming through the arch can cause the rock wall to be underexposed. I suggest that you take a light reading off the rocks and set the camera to manual mode and lock in this exposure. Otherwise the camera's light meter will attempt to darken the bright sunlight and underexpose the rest of the scene. This is also a great location to practice HDR—taking five to seven shots in quick succession about one stop apart and then blending them together in Photoshop. Another solution is to take two shots, one exposed for the rocks and one exposed for the light coming through the arch, and blend them together in Photoshop. I have seen some photographers using neutral-density filters when taking this image, but in this case filters are not helpful. While they will have the effect of darkening either the sky or the foreground, they don't address the issue of having a bright area in the middle of a dark area.

There are other things to photograph at Pfeiffer Beach aside from the arches. The sand has an unusual bluish to purplish cast and the color creates interesting graphic designs left by the receding waves. Also, when the creek is flowing in the winter it makes an interesting leading line toward the ocean, and the setting sun turns the water a golden color. After the sun sets, look at the beach to the north of the arches—the soft waves often make a strong image as the sky turns color in the twilight. Pfeiffer Beach is a great place to spend the afternoon into the evening, enjoying and photographing the changing landscape, details on the sandy beaches, and the arches just before sunset.

Recommendations in Big Sur

As you enter the Big Sur area from either the north or south, the road turns inland from the coast and passes through a heavily wooded area with a wide variety of restaurants, galleries, shops, camping areas, and lodging options. Protected by a ridge to the west, Big Sur escapes the summer fog that is characteristic of much of this coastline. There are no traffic lights or even bright lights in Big Sur, and the residents prefer it that way. There is a strong sense of community among the 1,200 or so people who reside in this valley and they live quietly up unmarked dirt roads, usually along the ridgelines. No houses can be constructed that are visible from Highway 1, and only a very few that were built before this restriction was put in place are visible. Big Sur has always been seen as a retreat and quiet place for artists and writers. Among those artists was the author Henry Miller, who lived in Big Sur from 1940 into the early 1950s. Today the Henry Miller Memorial Library contains an extensive collection of his books, and Coast Gallery Big Sur to the south sells signed lithographs.

There are many places in Big Sur to visit, spend the night, and enjoy a meal, from the casual to the upscale.

Big Sur River Inn is the first location you come to as you enter Big Sur from the north. This well-known resort has a warm and cozy restaurant with redwood walls, and in the summer you can sit outside along and in the Big Sur River. There is also a motel, gas station, grocery store, gift shop, and wireless Internet service. There are additional shops and galleries within walking distance, just south of the River Inn parking lot.

www.bigsurriverinn.com
800-548-3610; 831-667-2700

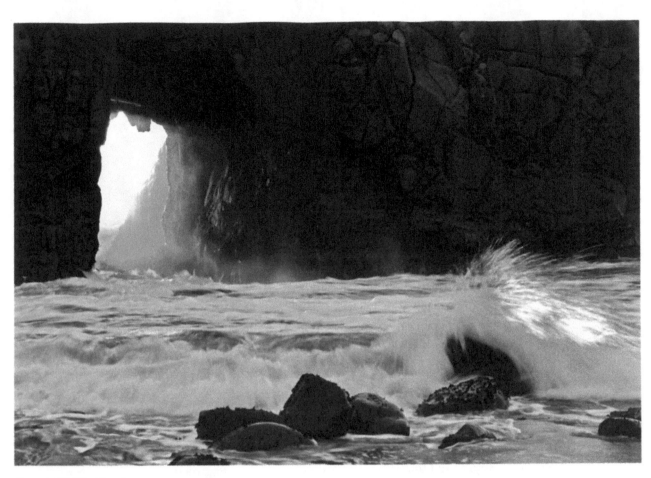

Sunset, Pfeiffer Beach

Heartbeat Gallery is located near the entrance to the Big Sur River Inn and features an eclectic and unusual collection of jewelry and collectibles from Big Sur and around the world, as well as interesting photography from the local area.

www.heartbeatbigsur.com
831-667-2557

Ripplewood Resort is located on the west side of Highway 1 about 27 miles south of Carmel. The charming resort has 27 cabins, some with fireplaces and kitchens, and is located along the Big Sur River among the redwoods. It also has a gas station, general store, and restaurant, which offers breakfast and lunch. Free wi-fi is available in the café.

www.ripplewoodresort.com
831-667-2242

Glen Oaks Big Sur contains fifteen comfortable and contemporary post adobe motel rooms and cottages, which are interspersed among beautiful gardens. All of the queen rooms have free wi-fi and no television. There is a feeling of being on retreat in this peaceful and accommodating environment.

www.glenoaksbigsur.com
831-667-2105

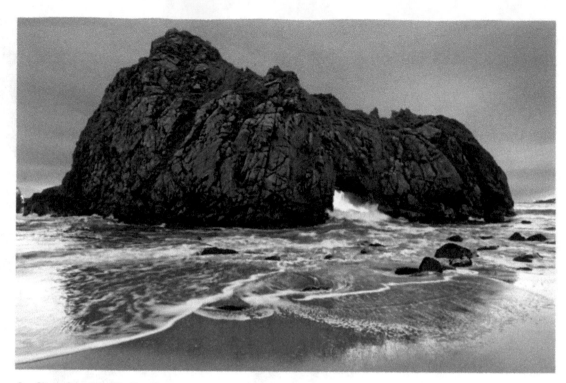

Sunlit arch at Pfeiffer Beach

Big Sur Roadhouse Restaurant is a casual dinner spot on the west side of Highway 1, across the street from the Glen Oaks Motel. This rustic restaurant is a favorite with locals and features fresh California and Latin cuisine every evening except Tuesdays, both inside and at the outside patio. Every summer a group of us ride our bikes down to this restaurant for dinner.

www.bigsurroadhouse.com
831-667-2264

Big Sur Lodge is located inside Pfeiffer Big Sur State Park and offers a variety of rooms, a restaurant, gift shop, swimming pool, and trailer and tent camping along the meandering Big Sur River. The park has many miles of hiking trails including trailheads leading into the backcountry. A favorite hike among the locals is the 4-mile uphill trek to the summit of Mt. Manuel. This hike has an elevation gain of about 3,000 feet.

www.bigsurlodge.com
831-667-3100

Big Sur Bakery and Restaurant is a favorite stopping place for locals and visitors. I rarely drive down the Big Sur coast without stopping in for a cappuccino and to buy a loaf or two of the freshly baked bread. I recommend that you purchase two loaves, because you may find that one will be gone before you arrive at your destination.

www.bigsurbakery.com
831-667-0520

Ventana Inn and Spa is a luxurious resort situated high above Big Sur and is nestled among meadows, woodlands, and gardens. Strikingly designed by local architect Kipp Stewart, the

rooms and restaurant feature natural wood walls and ceilings, with hand-hewn posts and beams. The patio of the restaurant has sweeping views over the Pacific Ocean and there is an adjacent gift shop. Ventana offers a luxurious and secluded location where you can escape for a romantic and pampered weekend.

www.ventanainn.com
831-667-2331

Post Ranch Inn is located on the cliffs overlooking the Pacific Ocean and offers two types of rooms. Tree house rooms are sprinkled among the redwoods, and cliffside rooms are perched high above the sweeping coastline of Big Sur with panoramic views. This luxury resort has received international accolades and offers spa treatments, massage, and yoga classes. The resort and its on-site restaurant, Sierra Mar, were designed by the internationally recognized architect Mickey Muennig, and Muennig's style is particularly notable in the restaurant, which incorporates his trademark glass and steel design. The side of the restaurant perched above the ocean is all glass, which makes you feel as though you are floating above the sea. The award-winning Sierra Mar offers a four-course, prix fixe menu for dinner and an extensive wine collection.

www.postranchinn.com
800-527-2200; 831-667-2200

Nepenthe Restaurant is arguably the most well known of all Big Sur destinations and has been a landmark for locals and visitors for many years. A trip to Big Sur is not complete without stopping for lunch on the beautiful deck of Nepenthe, where you can relax in the afternoon sunshine and enjoy the expansive views of Big Sur and the Pacific Ocean to the south. Ask to be seated at the patio in the rear of the restaurant, which has spectacular views and more afternoon sun in the winter. After lunch you can visit the on-site Phoenix Gift Shop, which offers an eclectic collection of spiritual treasures from around the world.

www.nepenthebigsur.com
831-667-2345

Henry Miller Memorial Library is located just south of Nepenthe and offers a complete collection of books and memorabilia by this famous author. The library also hosts a variety of events throughout the summer months, from films to live music to visiting writers, and offers wi-fi Internet access.

www.henrymiller.org
831-667-2577

Deetjen's Big Sur Inn offers a unique and authentic Big Sur experience. The rustic cabins and restaurant have a storied past and have been occupied by well-known writers, artists, movie stars, and tourists. If you spend a night in one of the cabins be prepared for a cat to jump on your bed in the middle of the night, and be sure to read and add to the sometimes steamy diaries that are a Deetjen's fixture. I recall reading one quote that went something like, "Well, after last night, I know he's not the one for me!" The restaurant offers romantic candlelight dinners, but my favorite meal is the excellent breakfast.

www.deetjens.com
831-667-2378

Hawthorne Gallery features the work of various members of the extended Hawthorne family and a few select artists from around the country. The striking building was designed by the well-known Big Sur architect Mickey Meunnig, who also designed the Post Ranch and numerous homes tucked away in the hills of Big Sur. I highly recommend a stop to see the contemporary paintings, sculpture, glasswork, and other media on display.

www.hawthornegallery.com
831-667-3200

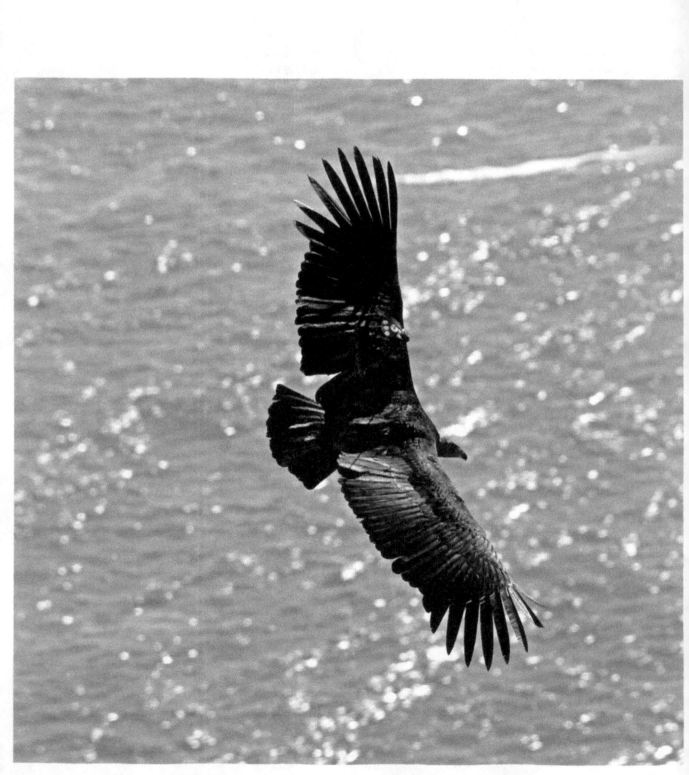

California condor in flight

V. South Coast of Big Sur

As you leave the community of Big Sur, Highway 1 quickly rejoins the coast for the dramatic drive down to San Simeon and Hearst Castle. This southern part of the coast is quite different from the area north of Big Sur. The cliffs and sea stacks have a distinctly darker color; they are gray and black instead of the reddish-brown hue that is so common along the northern stretch of the highway. Also, the road rises high above the ocean in several locations, and the frequently intimate views of the northern coastline are replaced here with grand, panoramic vistas.

Grimes Point (47)

Between mile markers 41 and 42;
GPS coordinates: 36°12'20" N, 121°44'8" W

As you drive south on Highway 1 past mile marker 42, you will see a driveway leading to a recently remodeled A-frame house out on a point. Shortly after this driveway is a large turnout to the right. The turnout is a good location for spotting condors, which can frequently be seen riding the thermals created by the very steep cliff rising up from the beach. It is worth a stop to see if any are in the area. I have had them soar over my head along the road here so close that I could hear the wind noise created by their very large wingspan.

Partington Cove and Partington Creek (48)

Between mile markers 37 and 38;
GPS coordinates: 36°10'35" N, 121°41'38" W

If you are driving from the south, Partington Ridge, Creek, and Cove are several miles north of McWay Falls. If you are driving from the

north, watch for mile marker 38 and the large turnouts on either side of the road. There is a steel gate and an old, eroded road that is now the trail leading down the hill to Partington Creek and Partington Cove. This cove has a storied past, extending back centuries to the time when local Indians would launch their canoes into the relatively calm cove to trade up and down the coast. In the late 19th century this area was settled by John Partington and his wife and five children. He was attracted by the tanbark oak and redwood in the nearby canyons and created Partington Landing. The rusty old fittings and concrete pilings of this landing are still visible today, embedded in the granite rocks just above Partington Cove.

As you walk down the trail, an old redwood bridge crosses Partington Creek and leads through a 50-foot tunnel to Partington Cove. This is a great location for photography because you can get close to the water and the waves as they surge in and out of the cove. You can almost imagine the tall schooners anchored offshore, taking on loads of tanbark, lumber, and cattle in the 19th and early 20th centuries.

My favorite location at the bottom of this trail is not the cove but Partington Creek. You don't have to walk very far upstream to a clearing where you can get nice images of the water as it cascades over the boulders. This is a good area to practice different exposure settings by

Partington Cove

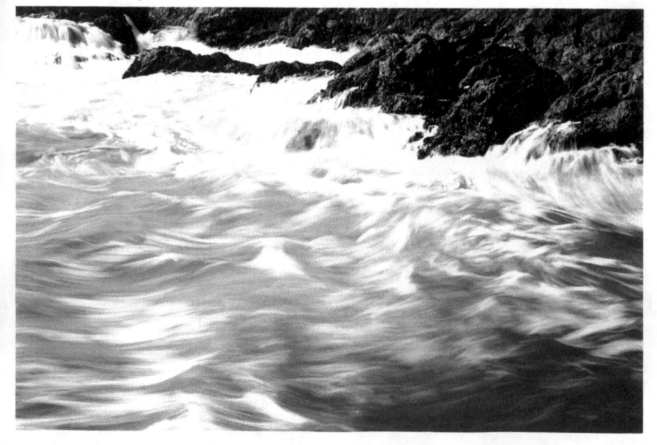

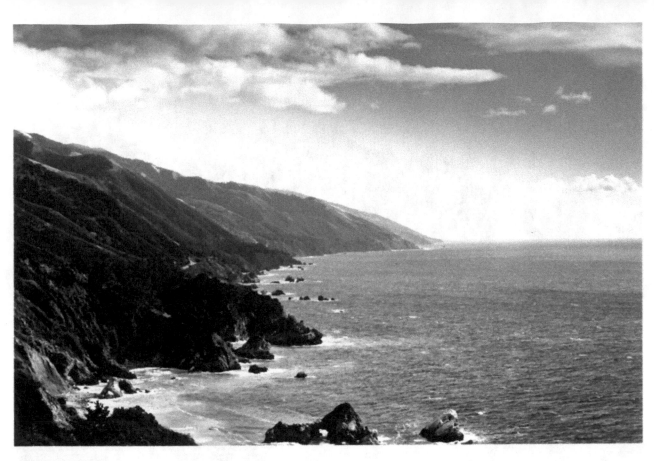

Big Sur's South Coast

either adjusting the ISO or the aperture settings to make the water appear soft and silky or turbulent. Shutter speeds at 1/15th of a second or slower will smooth out the movement in the water, while fast shutter speeds of 1/125th of a second or faster will capture or freeze the movement of the water. Be sure to use a tripod to stabilize the camera for slower shutter speeds. This area is usually in the shade, which avoids the highlights that are created by sunlight on water.

Large Paved Turnout at Mile Marker 37 (49)

GPS coordinates: 36°10'11" N, 121°42'5" W

The large paved turnout at mile marker 37 has a sweeping view of the Big Sur coastline to the south, with a series of overlapping ridgelines and ravines running diagonally down to the ocean. This is an iconic view of the Big Sur coastline and has been recorded by numerous photographers. I always stop at this turnout when driving up or down the coast and I almost always take a picture, because the changing conditions yield different shots. It is a strong image any time of the day, but I find it particularly interesting in cloudy or foggy weather, when the sun's reflection off the water is not too strong. In the morning hours when the sun is behind the high hills to the east, the coastline is in shade, whereas in the afternoon the hills are lit by the sun as it sets in the west. In the winter and spring wildflowers on the hills can be placed in the foreground of your shot to give a sense of depth and perspective.

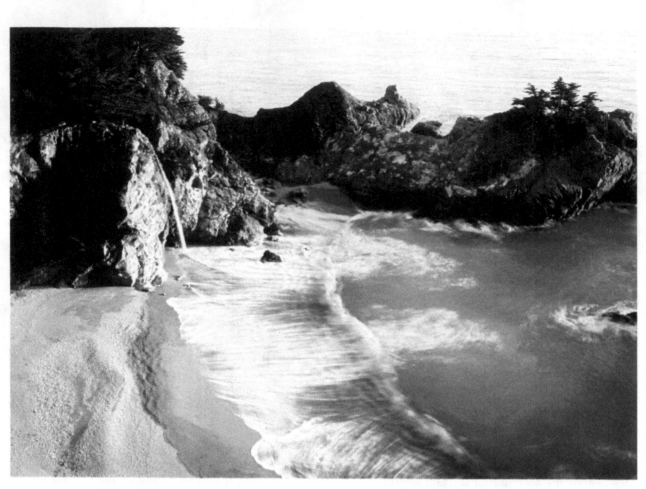

McWay Falls

Julia Pfeiffer Burns State Park and McWay Falls (50)

Mile marker 35.85;
GPS coordinates: 36°10'11" N, 121°41'6" W

Julia Pfeiffer Burns State Park provides the entryway to McWay Falls, one of the most widely recognized and photographed images of the Big Sur coastline. The parking lot is to the east of the highway; once there, follow the Waterfall Overlook Trail, which leads through a tunnel under Highway 1 and continues north on a high bluff. Along this trail there are several locations with spectacular views of McWay Falls,

a small, 70-foot waterfall that runs year round and is the only waterfall in California that spills directly into the ocean.

McWay Falls is a good image any time of the day, but the best time to photograph it is in late afternoon just before sunset. During this time the low angle of the sun lights up the waterfall and warms the color of the sand on the beach in the foreground, making this a striking image with contrast between the warm and cool colors. Since this waterfall has been photographed numerous times and published extensively, you might try looking for an angle or perspective that is a little different. Farther

along the trail there are eucalyptus trees, the leaves of which can be placed in the foreground of your shot; or, depending on the time of year, wildflowers can be included in the image. If there are clouds in the sky, then the image can be made larger to include them; otherwise it is best to crop in more tightly around Saddle Rock and eliminate most of the sky. Saddle Rock is the large, rocky peninsula that appears in the background behind McWay Falls; it has a dip in the middle, which makes it resemble a saddle. I usually use a polarizer for this image to reduce the glare off the water and slow the motion of the waterfall.

The northern end of this cliffside trail is also an excellent location from which to observe the California gray whales as they migrate south to Baja in December and January and north to Alaska in April and May. The whales come close to shore at this location and are easy to spot on calm days.

McWay Falls can also be photographed from Highway 1, just a little to the north of the entrance to the park. There is a turnout here and the waterfall is not readily apparent, but it will soon come into view as you walk a few steps along the side of the road.

Coastal Range View (51)

South of mile marker 30;
GPS coordinates: 36°5'10" N, 121°37'2" W

The large, elevated turnout just south of mile marker 30 has sweeping views both north and south. Looking north, the eroded coastal range drops a couple of thousand feet down to a rocky shoreline. The view to the south is not as expansive but can be very striking in the late afternoon when the sun is at a low angle. Both of these views are better when there are clouds in the sky. I use both a circular polarizer and neutral-density filter when taking images from this location.

Big Creek Bridge (52)

Mile marker 28;
GPS coordinates: 36°4'10" N, 121°35'55" W

Big Creek Bridge, a double-arched concrete bridge with half-arch side spans, is an impressive photographic subject whether viewed from above or below. For the latter view, park in the pullout immediately south of the bridge, which is located at mile marker 28. As you

Big Creek Bridge

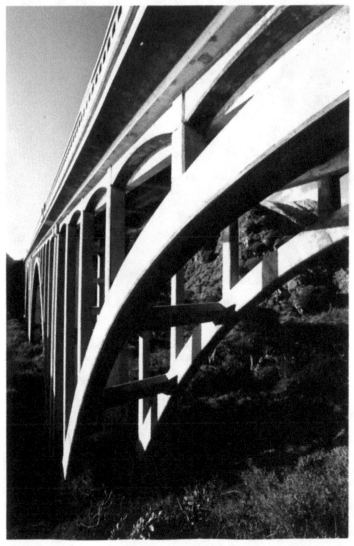

Fire damage at Limekiln Creek

approach the bridge on the ocean side, there is a small, precarious trail that leads down below road level. When shot from this position with a wide-angle lens, the bridge, with its combination of curves and beams, makes for a compelling composition. This photograph is best in the late afternoon when the sun is at a low angle and the sidelight creates an interesting interplay between shadows and sunlit areas. Be very careful on this slippery, narrow trail; it can be difficult to navigate—but the photograph is worth the effort.

View from Gamboa Point (53)

Mile marker 27.4;
GPS coordinates: 36°3'42" N, 121°35'30" W

From this large paved turnout about 0.5 mile south of the Big Creek Bridge, you can photograph the bridge from a distance against the rugged, eroded hills that drop precipitously to the ocean. This is similar to the shot of Bixby Creek Bridge from Hurricane Point, but in this case the foreground is blue water instead of the bluffs above the ocean. This shot is best taken

in the late afternoon when the bridge is well lit from the side, or on a cloudy day with no sunlight.

Limekiln State Park (54)

Mile marker 21;
GPS coordinates: 36°0.5'N, 121°31'W

Limekiln State Park offers campgrounds and photogenic hiking trails up Limekiln Creek. Limestone was shipped out of this canyon for a short time during the 1870s, and one trail leads up to the old limestone kilns, which are interesting to look at and possible subjects for a photograph. However, I prefer hiking about 0.5 mile up Limestone Creek to the spectacular Limekiln Falls, which spills about 100 feet over a vertical limestone wall. It is easy to hike in and get close to this waterfall; take a wide-angle lens and circular polarizer to get the best shots. The only problem is that the waterfall is in sunlight for a large part of the day, so try to arrive early, late, or on a cloudy or overcast day. Often this trail is closed during the winter rainy

season when the creek is too high to cross easily and the bridges are removed.

Limekiln Canyon is one of the steepest along the Big Sur coast. It rises over 5,000 feet to Cone Peak in less than 3 miles, which explains the waterfall. Cone Peak is the second-highest mountain in the Santa Lucia Range, after Junipero Serra Peak.

Aside from the waterfall, the trail leads in the other direction, under the bridge, to a large rocky beach. Rocky beaches are challenging for photographers but this one has easy access and if the conditions are right with clouds at sunset, the photographs can be dramatic. Don't forget to turn inland and look for photographs of the bridge above you.

www.parksca.gov
831-667-2403

Kirk Creek Trail (55)

Mile marker 19;
GPS coordinates: 36°59'23" N, 121°29'41" W

Kirk Creek Trail begins inside the Kirk Creek Campground and heads south between campsites 9 and 11. You do not have to stay in the campground to enjoy this trail, just park your car at the turnout on Highway 1 near the entrance and walk in. This short trail heads downhill, following Kirk Creek to the ocean. The creek offers several nice locations for intimate photography of the small waterfalls and flowing water, and there is also the rocky beach. Both of these areas make better images when the sky is cloudy or overcast, or late in the afternoon or evening before and after sunset. Since you are photographing water be sure to bring a polarizer to reduce the glare.

Highway 1 from Kirk Creek Trail

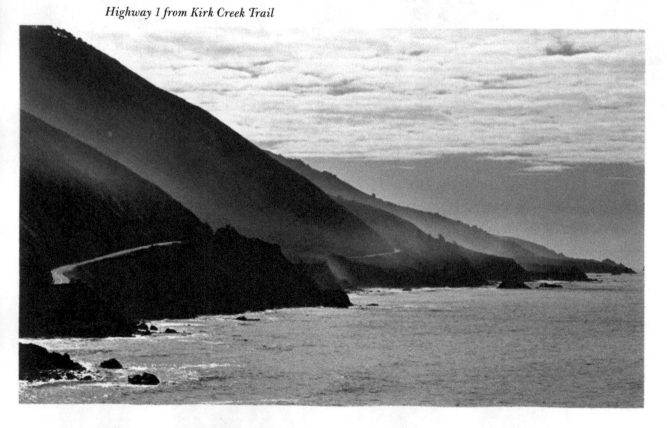

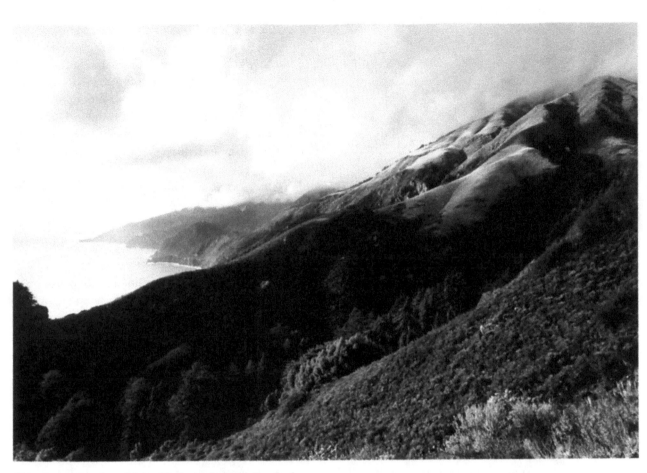

Clearing storm viewed from Nacimiento Road Overlook

Nacimiento Road (56)

Mile marker 18.9;
GPS coordinates: 35°59'8" N, 121°29'32" W

Nacimiento Road turns east off Highway 1 across from Kirk Creek Campground and eventually leads through Hunter Liggett Military Reservation and out to Highway 101. There are several locations on Nacimiento Road that I like for photography, and the first one is just 0.2 mile up the hill from Highway 1. This first turnout has a striking view of Highway 1 as it winds south along the coastline. I particularly like this view when the road is wet and the weather stormy. However, it offers an interest-ing perspective of the highway any time of the day. If you are photographing here at dusk or later, this is a good location to use a slow shutter speed and capture the streaming headlights or taillights of the cars as they drive up and down Highway 1.

Nacimiento Road Overlook (57)

GPS coordinates: 35°59'24" N, 121°29'26" W

This next location is about 1.5 miles up the switchbacks and curves of Nacimiento Road to the second turnout, which is on the left-hand side. From here you can capture a striking view

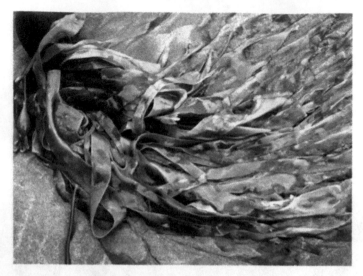

Kelp on Sand Dollar Beach

of the rolling hills to the north with the Pacific Ocean in the lower part of the photograph. I first took this image about ten years ago, just as a winter storm was clearing, and it has always been one of my favorites. I think it is best with the late afternoon sun lighting the hills, which gives them more depth and texture. In the winter months the hills turn much greener, but they make a strong image any time of the year when the lighting is right. This shot requires a wide-angle lens such as a 20mm or 24mm.

Sand Dollar Beach (58)

Mile marker 14;
GPS coordinates: 35°54'19" N, 121°28'1" W

Sand Dollar is a long, sweeping beach that is accessed from the National Forest parking lot on the ocean side of Highway 1. There is a fee to park in the lot. This beach reminds me of Pfeiffer Beach to the north in that they both have dark sand with traces of purple. As the tide recedes, the purple streaks make interesting compositions and patterns. These sand patterns are best photographed with a macro lens; be sure to stand directly above the pattern

you are photographing so the entire image will be in sharp focus. You want the plane of the scene to be parallel to the plane of the image sensor. If you photograph these patterns at an angle, there may not be sufficient depth of field to hold the focus throughout the image. A circular polarizing filter will minimize the glare that may result from the moisture in the sand. I have also found interesting kelp and rock formations when photographing along this beach.

Jade Cove (59)

Mile marker 13.3;
GPS coordinates: 35°54'48" N, 121°28'6" W

Although Jade Cove is not a particularly photogenic location, it is worth the stop for anyone who has an interest in geology. A flat trail leads across the bluff for about 100 yards before dropping steeply down to the cove. A rope assists hikers navigating the short, steep and slippery portion of the trail. In the cove there is a huge jade boulder with embedded crystals that you can stand on. On rough days the waves crash over the boulders in front of you, which can make for interesting photographs. At low tide on a calm day you can search for jade along the shoreline. (Although visitors are prohibited from removing jade from this beach, small pieces of it are offered for sale in several gift shops along this section of the coast.)

Cape San Martin (60)

GPS coordinates: 35°48'14" N, 121°27'38" W

The large pyramid-shaped rock of Cape San Martin reminds me of the yurt accommodations at Treebones Resort, which is located just to the south (see "South Coast Recommendations"). Every time I drive by this rock I want to photograph it, but the light has usually been too harsh. On a cloudy or overcast day the rock shows well against the turbulent surf all around it. This turnout is located just south

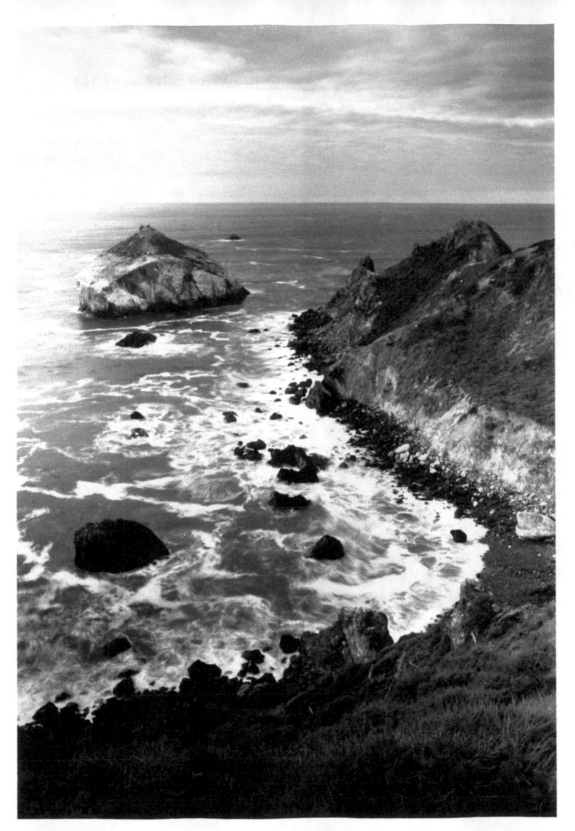

Cape San Martin

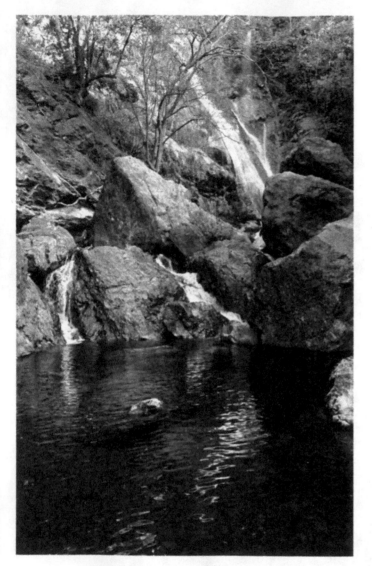

Salmon Creek Falls

Salmon Creek Falls (61)

Mile marker 2.2;
GPS coordinates: 35°34'56" N, 121°21'32" W

Salmon Creek Falls is located at the bend of a sharp hairpin turn along Highway 1. There is parking for quite a few cars along this bend, and from here you can hike up the creek. Be sure to take the southernmost trail, the one on the right as you are facing the waterfall. There is a sign at the trailhead, and the waterfall is about 100 yards up the trail. It is a fairly short and easy hike, but photographing Salmon Creek Falls can be frustrating because it is difficult to get a good vantage point and the volume of water is greatly reduced in the summer months. I try to find a location that includes some of the large pool in the foreground, which means hopping into the center of the stream onto the large rocks. Be careful, as the rocks can be slippery. I recommend a circular polarizer to take some of the glare off the water and to slow down the motion of the falling water.

This trail takes you through a small stand of redwoods, and if you are heading south from here, this will be your last chance to view them, as this is the southernmost point of these sequoia sempervirens, which extend north along the California coast into southern Oregon.

Salmon Creek Falls is the last location along Highway 1 in Monterey County; subsequent mile markers are preceded by SLO, to indicate that you are now in San Luis Obispo County.

Nature Trail at Ragged Point (62)

Mile SLO 72;
GPS coordinates: 35°46' N, 121°19' W

This large motel and restaurant complex on the west side of Highway 1 is a good place to pull off and take a rest after the tight switch-

of the large, paved Willow Creek turnout. Willow Creek Vista Point offers a different perspective on Cape San Martin and the large rock, but I don't think it is as dramatic or interesting as the view from the small turnout to the south.

backs on Highway 1 below Salmon Creek Falls. The short nature trail here goes along the top of a high bluff with expansive views of the rugged coast to the north, and this short walk offers some interesting photo opportunities. There are flower gardens along the trail and in a few locations it is possible to place flowers in the foreground of your image, with the receding coast fading off into the distance. This nature trail offers ample opportunities for macro photography or taking close-ups of flowers.

Viewing Area for Elephant Seals (63)

Mile SLO 62.4;
GPS coordinates: 35°39'36" N, 121°15'26" W

Just south of the Piedras Blancas Lighthouse on the west side of Highway 1 is a large, well-marked parking area from which you can observe and photograph elephant seals. These remarkable animals can be seen on this beach throughout most of the year, but the months of December and January are the most crowded and interesting. In early December the large bull males come ashore, engaging in violent fights for control of the harems of females. These large males are typically 15–16 feet long and weigh as much as two and a half tons. The dominant males do most of the mating, acquiring harems of 15 to 20 smaller females. In late December the females begin to give birth to the small pups, or weaners. Feeding on their mother's rich milk, these pups can grow to 250–350 pounds in a month or less.

The growth of this colony of elephant seals has been staggering. The first ones were spotted along this beach in about 1990, when a

Elephant seal portrait

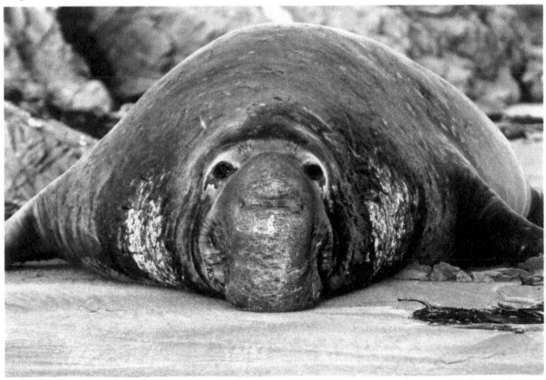

couple dozen came ashore. Now it is estimated that 15,000 come ashore every winter and they are increasing their territory to the north and south. Docents, identified by their green jackets, are on hand for much of the day to answer visitors' questions about the seals.

This has become my favorite location for photographing elephant seals because it is possible to get very close to them, and you can walk up and down the beach for a couple of hundred yards viewing the seals as they interact with one another. If you have the opportunity, spend the night in one of the nearby motels so that you can arrive at daybreak for photography. Elephant seals are more active in the cool early-morning hours and tend to sleep as the sun rises and the temperature increases. Also, the beach is much less crowded early in the morning.

I recommend using a telephoto lens such as a 300mm or 400mm for most shots, but a wider angle can also be used to take images of several seals together or to incorporate the background into your images. Wildlife photography requires a lot of patience and time to get strong images, but this is certainly the location to practice your skills. I always feel like I am "warming up" for the first 15 minutes or so and then my images begin to improve. Thankfully, digital photography gives you the advantage of shooting a lot of images and making decisions about which ones to keep and work on at a later time.

A flash can be helpful in taking these shots, especially on sunny days when it can balance out some of the shadows or dark areas created by the sunlight. If the elephant seals are interacting or moving, be sure to use an open aperture so you are able to shoot with a fast shutter speed. This may also require increasing the ISO. As a general guideline the shutter speed should be about twice the focal length of the lens to freeze the action of a moving animal. In other words, if you are shooting with a 400mm lens, the shutter speed should be 1/800th of a second or faster.

Friends of the Elephant Seal
www.elephantseal.org
805-924-1628

Hearst Castle (64)

Mile SLO 57.8;
GPS coordinates: 35°39'1.36" N,
121°11'10.18" W

Hearst Castle, or *La Cuesta Encantada* (the Enchanted Hill), is one of the largest attractions along the central California coast. With its 165 rooms and 127 acres of gardens and patios, the castle is the most majestic private home ever constructed in the United States. William Randolph Hearst was the only son of George and Phoebe Apperson Hearst, who made their fortune in ranching and mining. In 1887 George Hearst gave his 23-year-old son, William, the *San Francisco Chronicle,* which launched his career as a publisher. Between the years 1895 and 1920, William Randolph Hearst acquired 30 newspapers, numerous magazines, eight radio stations, and several film production companies. Both he and his father were prodigious art collectors, and Hearst Castle was designed to be a showplace for their art and antiquities collections; Hearst spent over a million dollars a year over a span of 50 years acquiring artworks and installing them in Hearst Castle.

The architectural design of this lavish estate was a collaborative effort between Julia Morgan, a pioneering female architect, and William Randolph Hearst. Morgan graduated from the University of California at Berkeley with a degree in civil engineering, and then became the first woman graduate of the École des Beaux-Arts in Paris. She designed a number of residences and buildings for W. R. Hearst, but

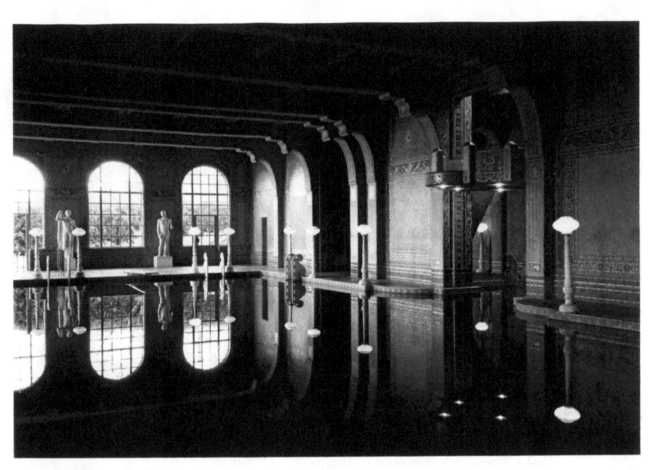

Roman Pool, Hearst Castle

Hearst Castle is the most well known and widely recognized.

In the early 20th century the castle became a destination or gathering place for the Hollywood elite, politicians, and prominent business people of the day. In addition to the art collection, Hearst had a large animal reserve and private zoo with lions, monkeys, wildcats, a black panther, an orangutan, and many other species. Today zebra can still be seen from Highway 1, grazing, along with cattle, on the hillsides south of the castle.

Hearst Castle was donated to the state of California by the Hearst family in 1958, and was made into a state park. I highly recommend visiting Hearst Castle and taking one of the several tours that are offered. There are four basic tours, as well as special theme tours, such as the sunset tour on weekends. All of the tours include the famous Neptune's Pool—the Greco-Roman outdoor pool—and the stunning indoor Roman Pool, which is lined with gold and Venetian glass. In my opinion the dark blue pools are the most photogenic part of the tours, along with the rolling hills, which turn an emerald green in the winter. Be sure to take a tripod and a wide-angle lens to make the most of these shots.

Tour reservations are highly recommended, especially in the crowded summer months.

Hearst Castle has a large gift shop, restaurant, and coffee bar.

www.hearstcastle.org
800-444-4445 (tour reservations)

San Simeon Pier (65)

GPS coordinates: 35°38'35" N, 121°11'14" W

The San Simeon Pier is located in the small town of San Simeon, directly across from Hearst Castle. This pier was constructed by George Hearst in 1878 to accommodate steamers bringing supplies to the property and enabling the family to travel from San Francisco by boat, avoiding the longer and more difficult overland trek. The pier is located in San Simeon State Park and is now used primarily for recreation: fishing is popular here, and visitors can stroll the pier, enjoying the pristine views. The park also has a grassy lawn and crescent-shaped beach, both of which are nice locations for relaxing and enjoying a summer afternoon. If you happen to be in this area in late March or April, you may spot mother and baby gray whales making their way north to Alaska. The whales often use this calm, protected cove to rest and are easy to spot from the vantage point of the high pier. When you're ready to take a break from photography, the nearby Sebastian's general store has a tea- and coffeehouse and serves up excellent sandwiches and soups.

I have photographed this pier from several locations; my favorite shot is from underneath, viewing it on the beach through a wide-angle lens. The vertical posts and left-hand curve of the structure make for an interesting composition. Very early in the day, when the pier is vacant, its graphic design is accentuated as the early-morning sun lights it from the side. I recommend using a circular polarizer to reduce the glare off the water and slow down the wave motion of the water.

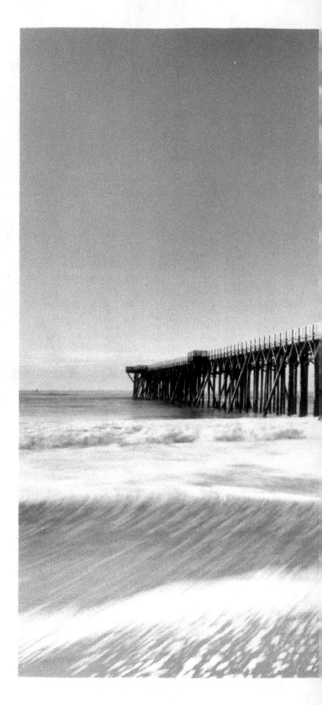

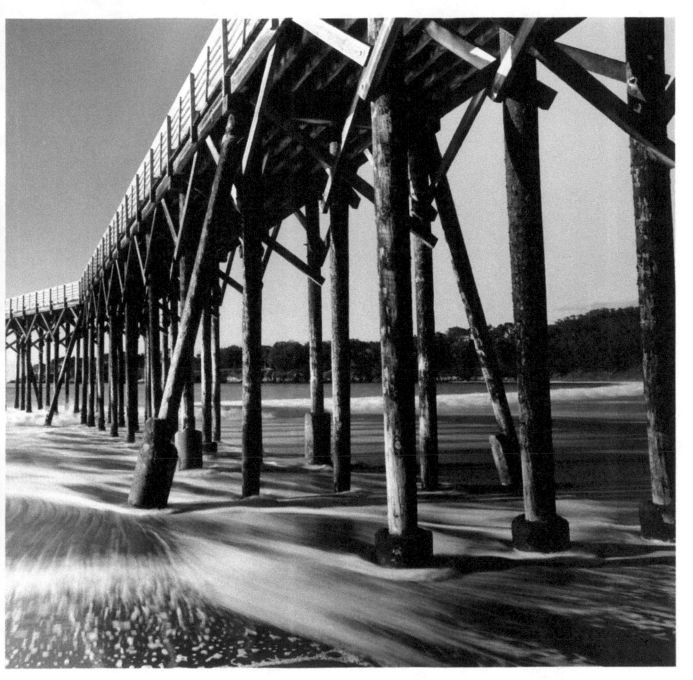

San Simeon Pier

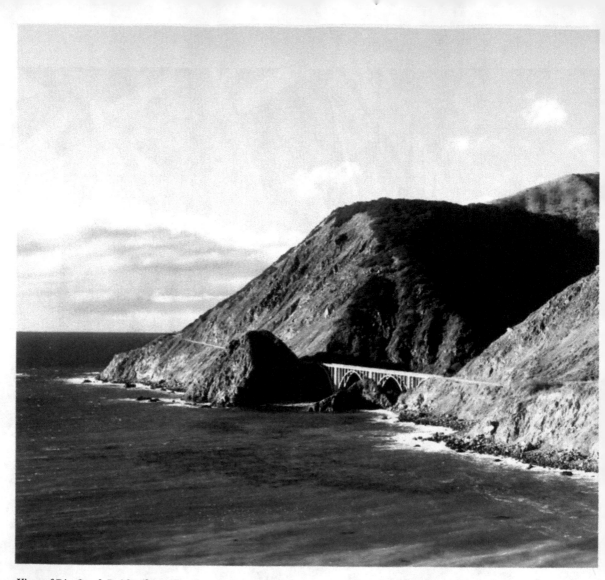

View of Big Creek Bridge from Gamboa Point

South Coast Recommendations

Coast Gallery Big Sur is located several miles south of Big Sur at mile marker 40.9. Distinctively built from large recycled redwood water tanks, this expansive gallery has several large gallery rooms, a Henry Miller Art Museum, and a café. Open daily.

www.coastgalleries.com
800-797-6869; 831-667-2301

Lucia Lodge has a restaurant that opens to the ocean, a small shop, and 10 unique cliffside rooms located high above the Pacific with sweeping views to the south. Lucia Lodge was originally established in the 1930s by the Harlan family, and their descendants still operate the motel and restaurant today. The rustic cabins do not have television or telephones, which adds to the charm and helps turn your attention to the majesty of the natural environment.

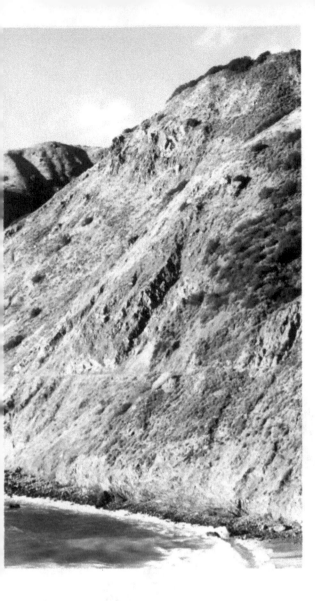

Dollar Beach. This is a fairly basic campground with no showers, sewer, or electrical hookups. However there are restrooms and water spigots located throughout the campsites.

www.campone.com
805-434-1996

New Camaldoli Hermitage is located just south of Lucia Lodge on the eastern or inland side of Highway 1. This is a self-sufficient community of Camaldolese monks who live quietly in the hills of Big Sur, devoting their lives to prayer and contemplation. The Hermitage has a gift shop, and arrangements can be made for individual or private retreats on the grounds where guests can enjoy the quiet and solitude of this remote location.

www.contemplation.com
831-667-2456

Gorda (mile marker 10.1; GPS coordinates 35°52' N, 121°26' W) is a self-described "stopover oasis" consisting of a restaurant, gas station, shops, lodging, and a general store. This portion of the Big Sur coast is well known

Male elephant seal

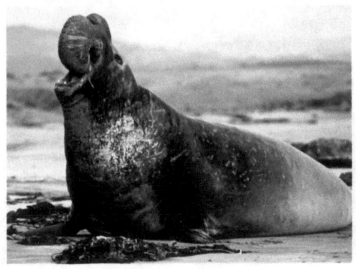

www.lucialodge.com
866-424-4687

Kirk Creek Campground (mile marker 19) is my favorite campground south of Big Sur. Most of the sites have grassy areas, which are more comfortable than camping on dirt. Also, the campground is located on a bluff overlooking the Pacific Ocean with spectacular views. There is one trail that leads down to the beach, or you can drive 4 miles south to the large Sand

for jade deposits, and Gorda hosts an annual Jade Festival during the first week of October.

www.gordasprings.com
800-927-4588 (lodging)

Treebones is a unique resort located above the Big Sur coastline with sweeping panoramic views to the north and south. The resort consists of 16 yurts, which are circular tent-like structures made of lattice wood and canvas. The rooms are comfortably appointed, with polished hardwood floors, queen-sized beds, and redwood decks. In addition to the yurts there are 5 campsites, a guesthouse, and a "human nest." Treebones also has a swimming pool, restaurant, gift shop, and sushi bar, all of which combine to offer a unique Big Sur experience.

www.treebonesresort.com
877-424-4787

Ragged Point is a large complex off Highway 1 that includes lodging, a restaurant and snack bar, gas station, and panoramic views of the Big Sur coastline to the north from its nature trail (see description at location 62). It is on the ocean side of the highway, about 15 miles north of San Simeon. Ragged Point offers a nice stopover for lunch on the outdoor patio, which is very comfortable on warm, sunny afternoons.

www.raggedpointinn.com
805-927-4502

Partington Creek

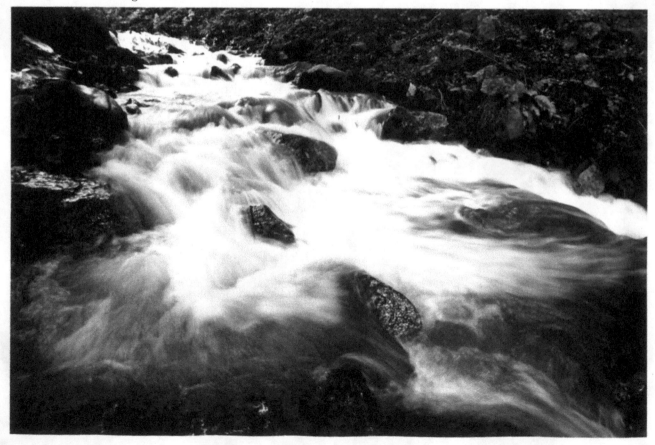

CPSIA information can be obtained
at www.ICGtesting.com
Printed in the USA
LVHW061419110221
679057LV00001B/16